MW00697900

Content

02 Prologue

10 Intro
A Hip-Hop Roadtrip

14 Hamburg
Half of Two

26 Berlin
The Beat of the Street

46 Breaks and Bach
The Passion for Breakdance

52 Amsterdam
On Light Soles

66 Fashion and Fame
Hip-Hop and Fashion

72 Barcelona
Between Heaven and Hell

86 Drawings on the Wall
The Corporate Identity of the Street

102 Paris
Paris Has the Flow

116 Punchlines
Curse and the 10 Laws of Rap

122 Homies, Bosses and Lamb Kebabs
Hip-Hop and Language

128 Stuttgart
The Bubbling Cauldron

140 Foreign in My Own Country
Hip-Hop and Society

148 London
Forging Its Own Path

164 Copenhagen
Freedom in Danish

184 Sounds of Europe
Historic Hip-Hop Milestones

196 Hip-Hop Icons
Classics of a Youth Culture

202 Glossary
Hip-Hop from A to Z

206 Viva con Agua
Water for All, All for Water

210 Back to Tape
The Movies

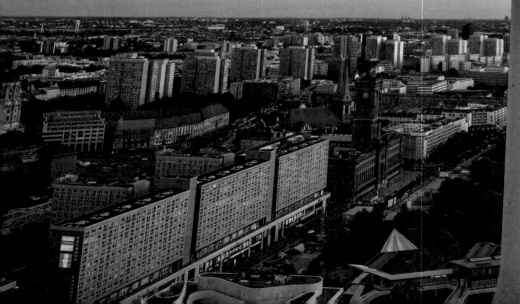

Hip-hop is the largest urban youth culture in the world. For over 30 years, the four core elements of rap, graffiti, Djing and breakdance have shaped entire generations — and with them, major cities all over the world.
Back 2 Tape is a roadtrip that shows one thing above all others: hip-hop has the power to unite people, regardless of nationality, faith, language or origin.

– „Hip-Hop ist Familie." –

Kool Savas

Hip Hop Culture

– „Hip-Hop überwindet Grenzen." –

Niko Backspin

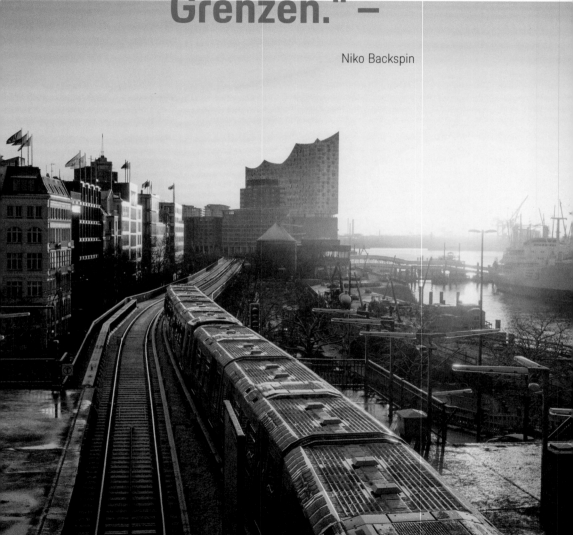

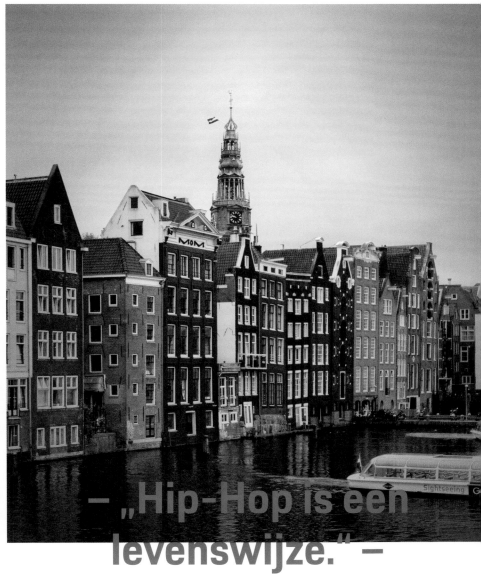

– „Hip-Hop is een
levenswijze." –

Edson Sabajo

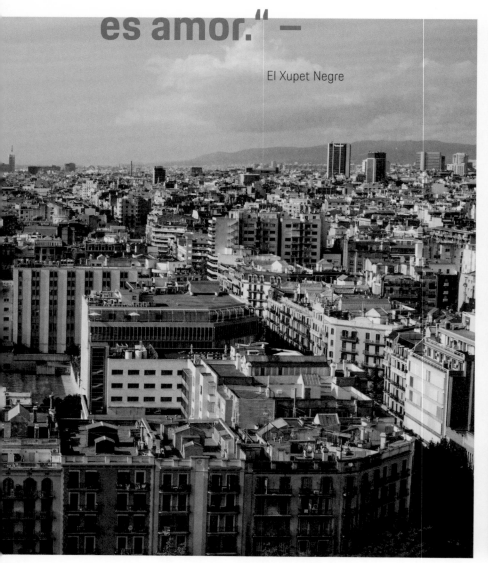

– „El hip hop es amor." –

El Xupet Negre

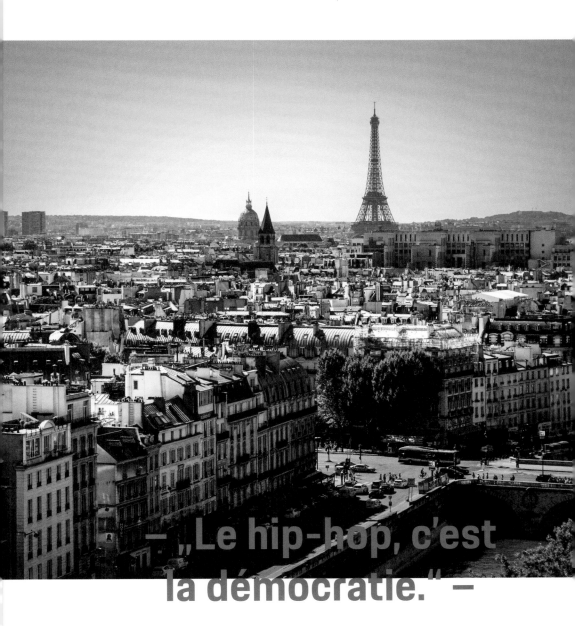

– „Le hip-hop, c'est
la démocratie." –

Lord Esperanza

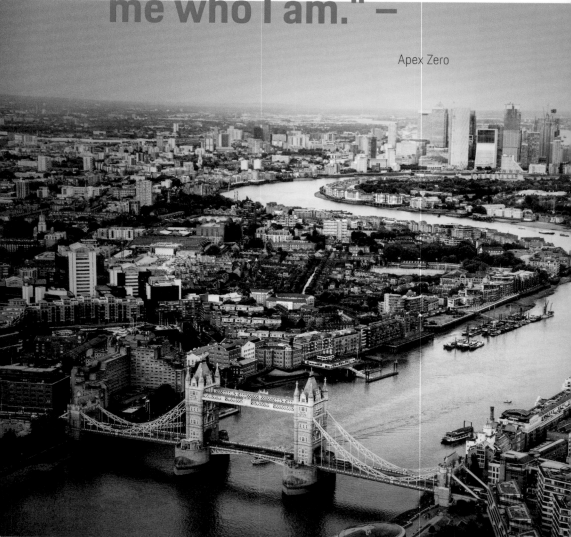

– „Hip-Hop showed me who I am." –

Apex Zero

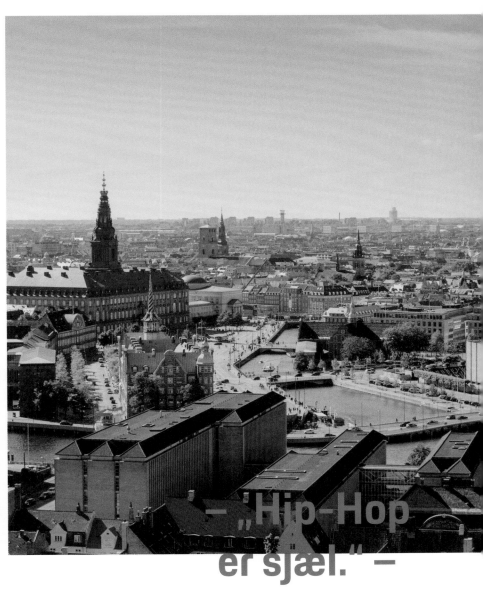

– „Hip-Hop
er sjæl." –

Sune Pejtersen

A Hip-Hop Roadtrip

Hip-hop and Porsche? For some MCs and petrolheads, the attempt to draw possible parallels is not necessarily met with a great amount of goodwill. However, that is what this journey is all about: we want to widen horizons, see beyond external appearances, and identify inner values. Hidden behind the façade are more similarities than one might expect.

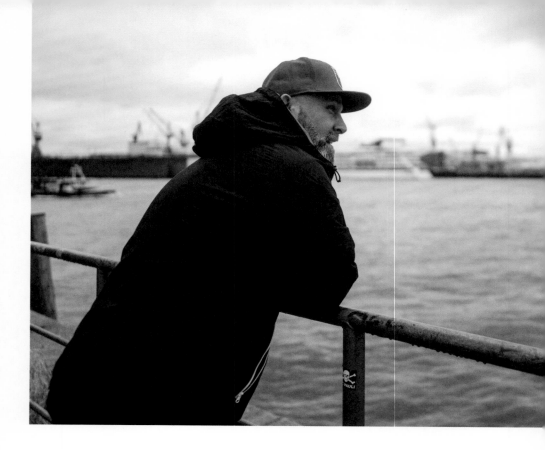

On this cultural trip through Europe, we discovered one thing in particular: no two stories are the same. For example, who would have thought that rappers and graffiti artists could have characteristics verging on conservative, as they do in Paris? And you certainly wouldn't necessarily believe that a local authority would officially commission a group of graffiti artists to embellish their community – see Copenhagen. By contrast, we could probably have guessed that many hip-hop stars, like Edson in Amsterdam, do indeed harbour a passion for shoes.

Even when meeting many of the guests on our tour for the first time, it took no more than a matter of minutes before the chemistry fell into place. The correct handshake, the right feeling, the sense of being on equal terms. The same feeling – not only for music or art, but for values, for respect. Is this only possible through hip-hop – or does it

have something to do with our lava orange mode of transport? When we launched *Back to Tape*, about four years ago, we did not expect the idea to develop this way. The fact that our initial idea to take a hip-hop roadtrip through Germany has now produced a book, as well as two documentary films and a cinema event attended by more than 700 hip-hop fans, has blown our mind. Visiting some of the most beautiful cities and streets on our wonderful continent has been just as humbling as meeting artists who have helped shape the largest urban youth culture for going on 30 years. And we don't mind saying that we are more than a little proud of what we have achieved.

Take this travel and cultural guide as an invitation to openly encounter European (hip-hop) culture in all its diversity. Take it as an adventure, the destination of which is the journey itself – an adventure that, even when you close this book, is far from over.

The Format.

In 2018, music journalist Niko Hüls set off on a journey to the roots of hip-hop in Germany in *Back to Tape*. He followed this in 2020 with *Back 2 Tape* – a roadtrip through Europe in a Porsche Cayenne S Coupé. In cooperation with hip-hop magazine *Backspin* and over 30 international artists, the two projects highlight the cultural impact that the four central elements of hip-hop – rap, DJing, breakdance and graffiti – have on cities.

Consumption details
Porsche Cayenne S Coupé (as of 3/2021)
Fuel consumption, urban: 12.8 l/100 km
extra-urban: 8.2 – 7.9 l/100 km
combined: 9.9 – 9.7 l/100 km
CO_2 emissions combined: 225 – 222 g/km

Hip-hop is life, just like water. For this reason, we took the decision together with Porsche to donate the proceeds of the sale of this book to the organisation Viva con Agua. The goal of the charity, which was founded in the Hamburg quarter of St. Pauli, is to allow people all over the world access to clean drinking water and basic sanitation. With its WASH project (Water, Sanitation, Hygiene), Viva con Agua is committed to improving the water supply in many countries, including Uganda, Ethiopia, Mozambique and South Africa, and to quenching the world's thirst. We feel this is a quite wonderful project that is most certainly worthy of support.

So, enjoy the read.
Safe travels!

Niko Hüls and the *Back 2 Tape* crew

http://newsroom.porsche.de/back2tape

 @back_to_tape

 @backtotape

#BackToTape #Back2Tape

Hamburg 53° 33' 55" N 10° 00' 05" E

Rap • Journalism • Breakdance

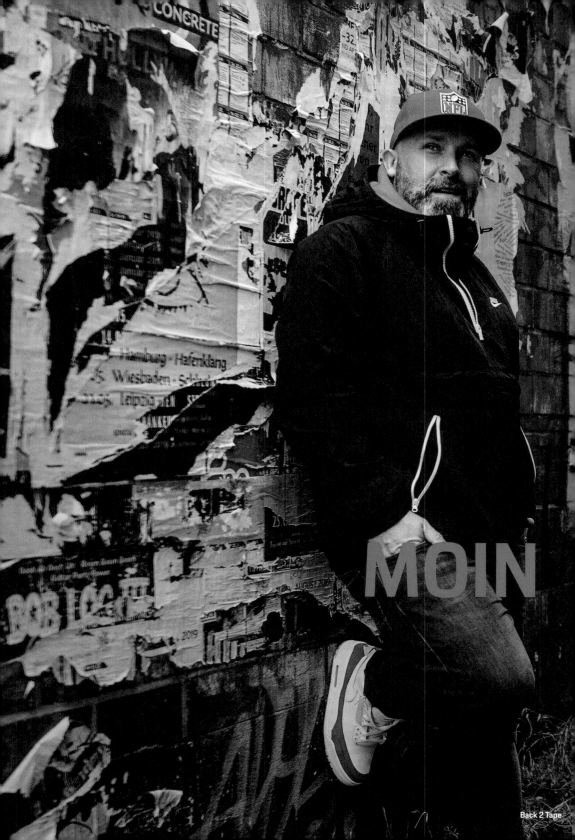

MOIN

NIKO HÜLS

Niko Hüls, aka Niko Backspin, is a German
music journalist, photographer, presenter and
ambassador for *Viva con Agua*. Born in Hamburg,
he has been part of the hip-hop scene for more
than 25 years, since 2002, producing content for
Backspin, a magazine & web TV format for rap,
DJing, breakdance and graffiti. Always authentic,
and with a finger on the cultural pulse, he is
constantly on the lookout for the next interesting
story. In 2018 and 2020, Niko took a hip-hop
roadtrip across Europe for Porsche.

Hamburg 53° 33' 55" N 10° 00' 05" E

The history and mindset of Hamburg are both closely linked to
the port — the door to the world. This openness to the world is
also reflected in northern Germany's hip-hop culture. Artists
like Jan Delay, *Fettes Brot*, *Deichkind*, Das Bo, Ahzumjot and
Samy Deluxe all began their careers there — and became legends
way beyond the boundaries of the city on the River Elbe. The
next generation has also well and truly conquered the German
rap scene. Always in the thick of it and connected to everyone —
hip-hop original, music journalist and host of the *Back to Tape*
series, Niko Hüls aka Niko Backspin.

**It's 2018 – the year the story of *Back to Tape*
began. In the beating heart of Hamburg, Niko
Backspin sets off on his journey to the roots of
hip-hop across Europe. He takes a last look at
the port, the waves of the Elbe, the container
ships, his homeland. The stiff breeze carries a
vague scent of fish rolls, flashing to a distant
beat is the colourful flicker of the red-light
district. A light drizzle hangs in the air. It's all
very Hamburg. Heading out over the St. Pauli
Piers, we adjust our caps and embark on a road-
trip – one where the journey itself will be the
destination. *Und der Hafen, der ist das Herz, die
Bassline; Fuck Internet, wir warn schon immer
mit der Welt eins.* [And the port, that's the heart,
the bassline; fuck the internet, we were always
at one with the world]. *City Blues* by *Beginner*
from 2003 is a fitting soundtrack as the road
takes us past Park Fiction on the autobahn
towards Berlin.**

Niko Backspin is a city kid who grew up in
Hamburg's hip-hop culture. When *Dynamite
Deluxe* was formed in 1997, Hamburg hip-hop
magazine *Backspin* had already been around for
four years – set up and published by Bodo Falk
and Frank Petering. The first issue was published
in 1994, with a print run of 3,000 and a cover
price of 10 DM. It was a true labour of love – 44
pages, printed in black-and-white with twelve
four-colour graffiti pages. Its focus was on the
fundamental elements of hip-hop – rap, DJing,
graffiti and breakdance. In 2001, one of its
first paid photographers was a still completely
unknown Paul Ripke. Around nine years later,
once the culture of the Hamburg school had
kicked up a storm all over Germany, Niko took
over the reins as editor-in-chief and publisher.
With a young team of hip-hop lovers and the best
contacts on the scene, he grew Backspin into an
online magazine with a huge following on social
media, podcasts and its own online TV channel.
Interviews and video documentaries with rapper

Kollegah and 187 Strassenbande have clocked
up more than four million clicks on YouTube. The
brand defined itself through authentic, honest
music journalism with real substance – seeking
out truly interesting stories away from packed
concert venues, gossip or the next album
release. Niko Backspin became a brand in his
own right. He is the most in-demand "hip-hop
storyteller" of our time, connects artists with the
mainstream, always on the go, advising agencies
and businesses, a popular presenter, committed
ambassador for *Viva con Agua* and a presenter of
formats covering all aspects of hip-hop culture.
Niko travels the world, but is always a Hamburger
at heart.

A tribute to 1990s German rap
So, for him – and somehow hip-hop all over
Germany too – June 3, 2016 is a date of almost
historical significance, marking the return of
Hamburg to rap. The track *Ahnma* by *Beginner*,
made up of Jan Phillip Eißfeldt aka Jan Delay,

JAN DELAY

Jan Phillip Eißfeldt, aka Jan Delay, is a veteran of the German hip-hop scene, but has taken musical excursions into the funk, soul, rock or reggae genre during his career. A successful solo artist in his own right, Jan Delay is also one third of hip-hop combo *Beginner* (formerly Absolute Beginner). Jan Delay regularly calls out everyday racism in his texts in an intelligent and comical way and is actively involved in various social initiatives.

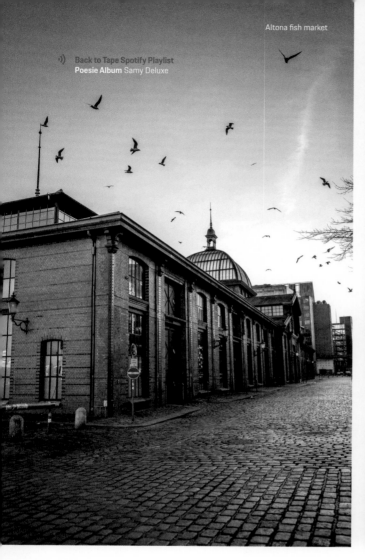

Altona fish market

))) **Back to Tape Spotify Playlist**
Poesie Album Samy Deluxe

Dennis Lisk aka Denyo and Guido Weiß aka DJ Mad, literally put Hamburg back on the map. When the first teaser images of the video shoot appeared on Instagram and Facebook and the title of *Beginner's* fourth studio album was announced, the hip-hop nation turned its eyes northwards in eager anticipation. On *Advanced Chemistry* – named after one of the first German hip-hop crews in Heidelberg led by Toni-L and Torch – Hamburg's headline rappers brought together generations of basslines and beats. Gzuz, Gentleman, Samy Deluxe, Afrob, Ferris MC, Dendemann, Megaloh and Haftbefehl lent their voices to the sampler. Hamburg's docklands were the backdrop for a music video that has racked up more than 55 million views to date. Although the album's music is the subject of much critical debate, it is nevertheless a tribute to the 90s and, in that respect, a cornerstone of German hip-hop.

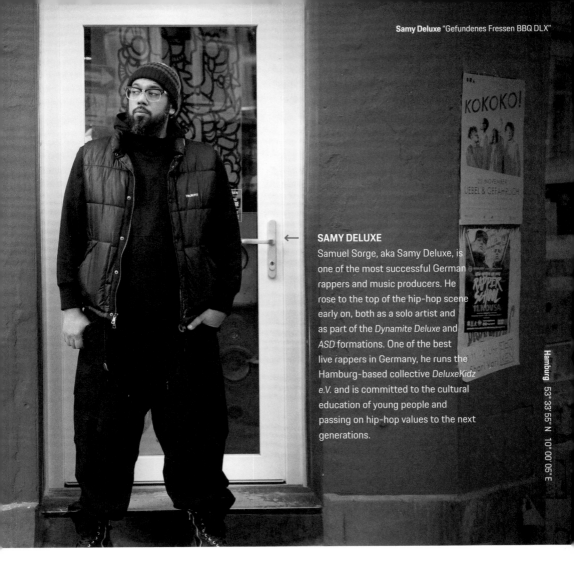

KOKOKO!

SAMY DELUXE

Samuel Sorge, aka Samy Deluxe, is one of the most successful German rappers and music producers. He rose to the top of the hip-hop scene early on, both as a solo artist and as part of the *Dynamite Deluxe* and *ASD* formations. One of the best live rappers in Germany, he runs the Hamburg-based collective *DeluxeKidz e.V.* and is committed to the cultural education of young people and passing on hip-hop values to the next generations.

Hamburg 53° 33' 55" N 10° 00' 06" E

The door to the hip-hop World

Once we have left the lights of the Hanseatic city far behind us and our roadtrip playlist is running on a continuous loop, Niko Backspin delves into his memories – of good rap stories, of the NDR radio show *Soultrain*, where, at the end of the 80s, Ruth Rockenschaub was already regularly playing soul, funk and the occasional bit of rap on the night time broadcast. He recalls DJ Marius No. 1 and his *Number One Mixshow*, the *Mitschnacker* EP by Fettes Brot and legendary hip-hop festivals at Hamburg's Millerntor Stadium. There's no way to overlook Hamburg – that much is certain. It's the city that

gave birth to some of Germany's biggest-ever rap hits such as *Füchse, Ladies & Gentlemen, Jein, Arbeit Nervt* and the participation of Ferris MC in *Reimemonster*.

There's no question that the city has produced many rap greats over the years, with Jan Delay, Dynamite Deluxe, Fünf Sterne Deluxe, Fettes Brot and Deichkind at the top of the list. Their music shapes generations. The line *Hamburg ist die Hälfte von 2; die Schönste, die Nummer 1* [Hamburg is half of 2; the best, the number 1] by Beginner represents the huge connection to the city that defines Hamburg hip-hop to this day – without any loss of openness to other influences and generations (in true Hanseatic fashion). The broad diversity of understated calm to loud, harsh tones later became evident in the success of Rapper Nate 57 from St. Pauli, Ahzumjot and the 187 Straßenbande.

Samsemilia – or the mindset of a culture movement

In 2018, for Back to Tape, Niko Backspin finally met one of the best rappers Germany has ever produced – Samy Deluxe. With more than one million record sales, he is still firmly anchored in the hip-hop business – as an MC, producer and talent promoter. His origins, his connection to the city – from Eppendorf to Eimsbüttel – his life without a biological father and his undying love of hip-hop in all its facets still feature heavily in his lyrics. As we drive together through his hometown, our Porsche is stopped by a police car – for the officers to take a selfie with Samuel "Samy" Sorge.

The career of *Samsemilia* began in 1997 with a mix tape by Dynamite Deluxe marketed single-handedly by Jan Delay. The demo tape went through the roof and led to other highlight albums like the debut *Samy Deluxe* and follow-

ups *Wer hätte das gedacht?* [Who would've thought it?] and SchwarzWeiss [BlackWhite] as well as awards such as the MTV Europe Music Award, the ECHO Pop and the Comet.

While, for many artists, rap tells powerful stories of violence or beautiful women, for Samy Deluxe, hip-hop is mainly about culture – a creative valve that gave him direction as a young man and the opportunity to turn every negative experience into something positive.

Important values for the next generation

And it's precisely this attitude that the MC is passing on to the next generation, to charities and clubs like his own project *DeluxeKidz e.V.*, which he is working on in collaboration with *Esche Hamburg* under the artistic direction of Christian Delles aka *Beat Boy Delles*. "You always apply yourself in those areas where you have the most experience and that you're most passionate about," says Samy Deluxe. "My thing has always been the youth."

His project gives children and young people of different ages, different backgrounds and different beliefs the space to be creative and to explore themselves and their passion. "First and foremost, it's a fantastic thing when you're young to have a leveller. It's not all about money and career," says Samy Deluxe. "It's simply about being able to do something amazing, work every day on your skills and feel yourself getting better. It's something you can also use later in life in everything else you do." Dance, street art, rap, DJing – all founded on the fundamental values of hip-hop.

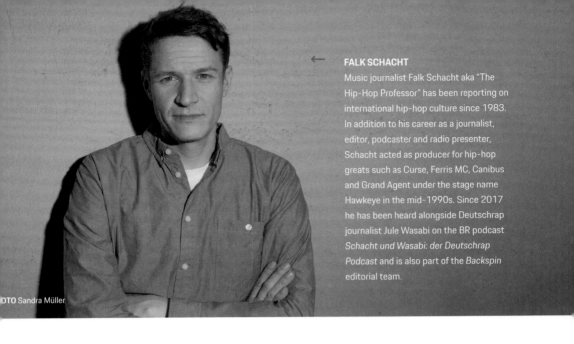

OTO Sandra Müller

Hamburg 53° 33' 55" N 10° 00' 06" E

The hip-hop professor.

If you're involved in the hip-hop movement in Germany, you'll definitely have come across Hanover native and Hamburger-by-choice Falk Schacht. In 2018, we ended our roadtrip through Germany for Back to Tape where it began – with a view of the docklands. Starting in 1994 with a column in music magazine of the time "Intro", Falk Schacht went on to work as an author, editor and director for KiKA, VIVA, the Goethe Institute, Wax Poetics, Jazzthing, Lodown Magazine, Word and The Message as well as for *Backspin*. These days, his German rap podcast *Schacht* & Wasabi with puls music on BR and the *Frag Falk* format are among the most important media formats in urban youth culture. "I like doing interviews, especially with artists whose music I don't like so much or whose content I don't agree with," says Falk Schacht, "because it confronts me with things I don't come across every day and that take me out of my comfort zone."

Alongside his career as a journalist, Falk Schacht also has a musical past. Working under the pseudonym *Hawkeye*, he produced for artists such as Curse, Ferris MC, Canibus and Grand Agent. He, too, has been fascinated by hip-hop culture since he was a kid.

– "Back then, for me, hip-hop was a very exciting playground full of robots, outspoken people and colourful imagery." –

he says. "It was just like a great big fairground, and it's still like that today to be honest," he says. When he gazes out over the Elbe from the distinctive dockland building, philosophises with Niko Backspin about hip-hop as if it were a religion, and describes for us his own personal feelings after more than 30 years on the scene, he needs very few words: **"Love. Simply love."**

PLACES TO GO & DRIVE

Hip-Hop Academy Hamburg
Hip-hop youth support project.
Öjendorfer Weg 30a
22119 Hamburg

DeluxeKidz e.V. – Jugendkunsthaus Esche
*Children and youth programme founded <
by Samy Deluxe.*
Eschelsweg 4
22767 Hamburg

Boogie Park Studios
Music production studio in Altona.
Eulenstraße 70a
22763 Hamburg

Kleiner Donner
Hip-hop club and bar on the Schanze.
Max-Brauer-Allee 279
22769 Hamburg

Graffiti-Hall of Fame Hamburg-Harburg
*500-meter-long graffiti surface on the
Bostelbeker Hauptdeich flood protection
wall.*
Bostelbeker Hauptdeich 2
21079 Hamburg

Park Fiction/Antonipark
Art and socio-political project since 1994.
St. Pauli Hafenstraße/Antonistraße
20359 Hamburg

Hamburg 53° 33' 55" N 10° 00' 06" E

Ber
lin.

Berlin 52° 31' 12" N 13° 24' 18" E

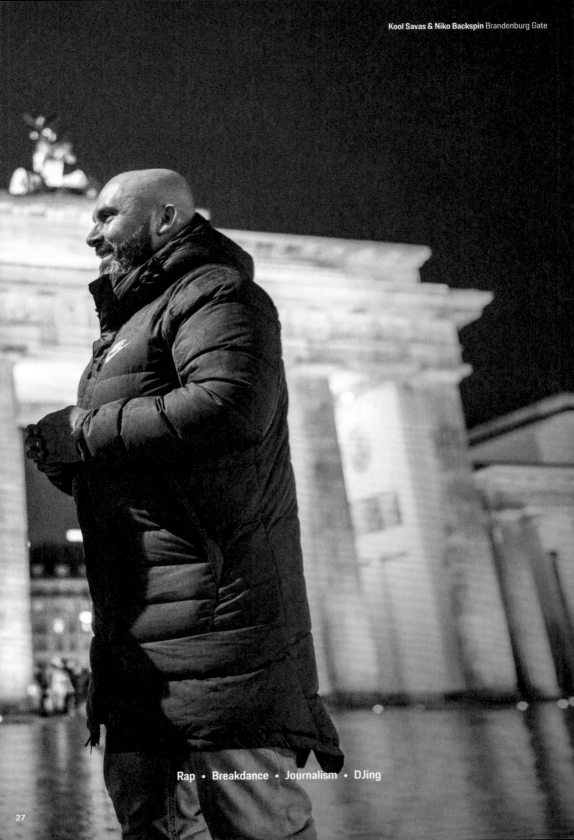

Rap • Breakdance • Journalism • DJing

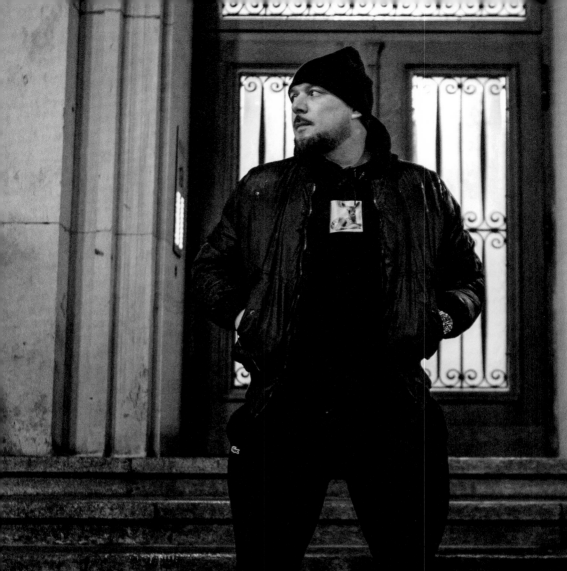

THE BEAT OF
THE STREET

Der beste Tag meines Lebens Kool Savas

KOOL SAVAS

Savaş Yurderi is better known by his stage name
Kool Savas. The "King of Rap" is considered one of
the most influential German rappers, shaped Berlin
hip-hop culture early on and is one of the chief
exponents of battle rap. Many well-known artists
still regard him as a role model. Tolerance is an
integral part of his idea of hip-hop. For Kool Savas
there is no racial aspect to rap, DJing, graffiti or
breakdancing, just respect.

Berlin 52° 31′ 12″ N 13° 24′ 18″ E

Berlin is not only known for techno and three-day parties, but has
also made a mark on the hip-hop scene. After years underground,
Kool Savas brought the aggressive sound of the street into the
charts. *Flying Steps* have taken breakdance to a new level and put
on successful shows around the world. In Miriam Davoudvandi and
Josi Miller, a new generation is now demanding new perspectives:

The "Berlinrap" livestream, with songs from Kool Savas, Pashanim and Serafinale, is a good way to get in the mood as the Porsche Cayenne takes us from Hamburg, along the inner-city A100, into the "Dicke B" (Phat B). This is how the *Seeed* crew lovingly christened their city in 2001: "Mama Berlin, bricks and gasoline. We love your smell when we paint the town red", set to a relaxed swing sound.

We take the Buschkrugallee exit and roll straight to Hermannplatz, the bubbling intersection between Kreuzberg and Neukölln. The busy square is by no means beautiful, rather an honest patch, which is well-suited to the local rap attitude.

We park the Cayenne near Ankerklause, where the weekly market on Landwehr Canal runs into Kottbusser Damm. On Sanderstraße, we drop into the Soultrade record store, which has made hip-hop tradition on vinyl its trademark. The window display features soul and funk classics from Gill Scott Heron, Funkadelic and Lonnie Liston Smith.

Owner Christian Abel has been preserving hip-hop history since its old-school beginnings, when the tracks were still mixed on turntables. The well-organised shelves start with Kurtis Blow or Grandmaster Flash and the Furious Five, and progress through to the 2020 album "RTJ4" by Run The Jewels. For anyone wanting to immerse themselves in the history of hip-hop, this is the place to be.

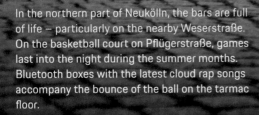

Berlin 52° 31' 12" N 13° 24' 18" E

In the northern part of Neukölln, the bars are full of life – particularly on the nearby Weserstraße. On the basketball court on Pflügerstraße, games last into the night during the summer months. Bluetooth boxes with the latest cloud rap songs accompany the bounce of the ball on the tarmac floor.

We cross the Landwehr Canal and head towards Görlitzer Park, where the tracks of the station of the same name once ran. Singer-songwriters and bands play from the ramps of the former goods halls. Spontaneous freestyle rap performances are regular occurrences on weekends. There is a relaxed atmosphere, guitar sounds mix with hard electro beats. A typical scene in SO36, as this part of Kreuzberg is known today, in recognition of its former postcode.

Between the Landwehr Canal and Silesia.

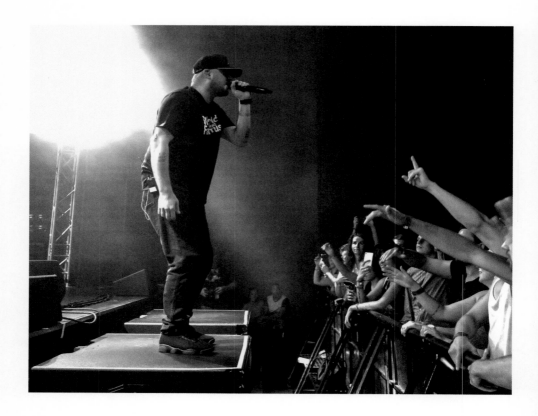

We take Line 1, an overhead railway that winds through Kreuzberg, to Schlesisches Tor, an epicentre for clubs like Lido, Bi-Nuu and Watergate. *Musik & Frieden*, next to the Oberbaumbrücke bridge, regularly hosts hip-hop parties over two floors. Overkill, a shop with roots in the graffiti scene, is also very nearby. Back in the early 1990s, the owners also founded a graffiti magazine by the same name, which reported on the sprayer scene.

In 2003, Thomas Peiser and Robert Schultz opened a graffiti accessories shop on Köpenicker Straße. You can still get cans and markers there today, but the Overkill team gained international renown with its exclusive range of sneakers. Since the owners have extended the former barbershop several times, and have opened a special shop for women's trainers next door, *Overkill* has been a Mecca for sneaker fans and collectors.

Kool Savas' territory.

Kreuzberg is the old district, to which West Berlin's legendary rapper Kool Savas moved with his parents as a 12-year-old – before the fall of the Iron Curtain. As a teenager, he experienced the era of the first graffiti crews and self-produced rap tapes from Waldemarstraße, within sight of the wall.

"Hip-hop always has something of the area you come from," says Savas today. "If you come

•)) **Back 2 Tape Spotify Playlist**
Rapfilm Kool Savas

from the ghetto, the style is more aggressive and rougher. It doesn't matter whether you rap, breakdance or graffiti. In Berlin, the concept of battles was always to the fore. Back then, bands like *KMC* and *Harleckinz* were automatically my enemies. Years later, I discovered that they are actually really cool guys."

The best day of his life.

After projects like *Master of Rap* and *Westberlin Maskulin*, Kool Savas released his first single *LMS/Schwule Rapper* in the summer of 1999. "My music was pretty crude, even by Berlin standards," Savas recalls. One year later, he set a milestone with the song *King of Rap*. He filmed the iconic video in the entrance to an apartment block on Karl-Marx-Allee. Savas left his ancestral district for the video, switching to what used to be the prestigious shopping mile in East Berlin.

A symbolic location, as the musical world was not the only one that had expanded for him. In 2002, he released his debut album "Der best Tag meines Lebens" (The Best Day of My Life), which took him into the official album charts and marked his commercial breakthrough. The battle rapper went on to establish himself as a German hip-hop great with the LPs "Tot oder lebendig" (Dead or Alive), "Aura", and "Gespaltene Persönlichkeit" (Split Personality).

No place for racial hatred

He has become an elder statesman of Berlin rap culture. "I have learned a lot and have worked hard," he stresses. "My relationship and contact with hip-hop are even more intense than ever." Through the street culture, he has learned values that apply to social behaviour.

– "Whether you are white, black, German, Turkish or Mexican – that has never been important to us." –

Tolerance and respect are core elements of hip-hop culture for Kool Savas. He feels it is just as important that he has never forgotten his history, despite all his success: "I can still play for 400 hardcore rap fans in a small, stuffy shop, and I am still respected."

Berlin 52° 31' 12" N 13° 24' 18" E

Consumption details
Porsche Cayenne S Coupé (as of 3/2021)
Fuel consumption, urban: 12.8 l/100 km
extra-urban: 8.2 – 7.9 l/100 km
combined: 9.9 – 9.7 l/100 km
CO_2 emissions combined: 225 – 222 g/km

♀ **PLACES TO GO & DRIVE**
Soultrade Recordstore
Record store in Kreuzberg
Sanderstraße 29
12047 Berlin

MICHAEL "MIKEL" ROSEMANN →

As a member of the *Flying Steps*, Michael "Mikel" Rosemann brought breakdancing to big venues without ever losing sight of the origins of the culture. Growing up in Berlin-Moabit, Rosemann has been dancing since 1991. Today he works as stage director within the Flying Steps Academy management team, also organizing international artist management and giving workshops for the local B-boy scene. Rosemann has succeeded in turning his hip-hop hobby into a career.

Berlin 52° 31'12" N 13° 24'18" E

While Savas took his energy from the rough SO36 in the 1980s and 90s, the district, with its furnaces and narrow backyards, has long since become a trendy creative quarter. The streetscape may still appear rough and unruly, but it is impossible to ignore the process of change through renovation and rental increases.

Another feature of the new Kreuzberg is the Flying Steps Academy. Since 2013, the former Aqua Werke factory premises, a few steps from Moritzplatz, have been home to the largest urban dance school in Germany. As well as red brick halls, excavations and the mirrored window facades of brand-new office complexes herald the transformation of the former residential area. Amidst all this, nightlife still has a place, thanks to underground clubs like Ritter Butzke in a nearby courtyard.

Michael "Mikel" Rosemann has witnessed the rise of hip-hop in Berlin from its very outset. As a teenager from Moabit, he discovered dancing amidst an environment of graffiti and rap in the early 1990s.

**– "To me, hip-hop always meant freedom.
It opened every door to me.
I had to go my own way, without anyone
telling me what to do," –**

explains Rosemann. Together with friends he formed a local crew, practiced in youth centres, and soon switched to Flying Steps.

Global dance success.

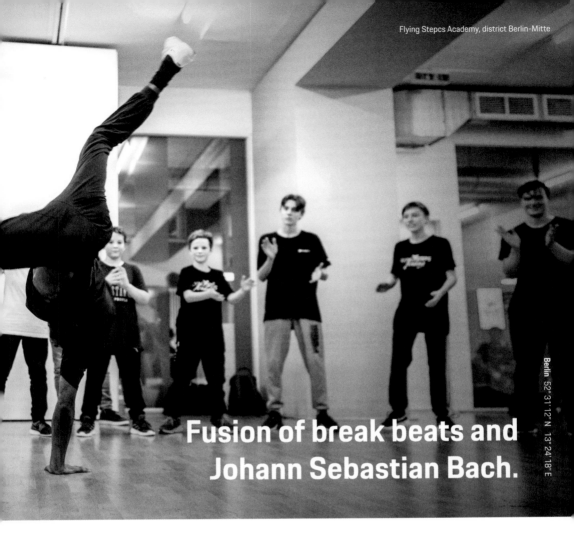

Berlin 52° 31' 12'' N 13° 24' 18'' E

Fusion of break beats and Johann Sebastian Bach.

While musical colleagues were able to fall back on an established environment of record companies and tour agencies, breakdancers had to create their own structures. *Flying Steps* successfully made the transition to professionalism, with talent, perseverance and a real community spirit. Nowadays, they are the best-known breakdance group in the world. Since 2008, *Flying Steps* have been dancing to a fusion of break beats and Johann Sebastian Bach's *The Well-Tempered Clavier* in their spectacular show "Flying Bach". A global success, with which they have taken their dance culture to a new level.

Even in its birthplace of the USA, breakdance has come to the attention of a wider public again. "I often give workshops when I am on the road, including in America. I still can't believe it. The country, from which this culture originated, wants to learn from a guy from Berlin," says Rosemann. The bright, spacious Academy studios, with 35 lecturers and 20 different dance styles – from Afro and house to dancehall – are the result of this constant development. You have to keep your mind open to new genres and styles. After all, the musical environment is changing all the time.

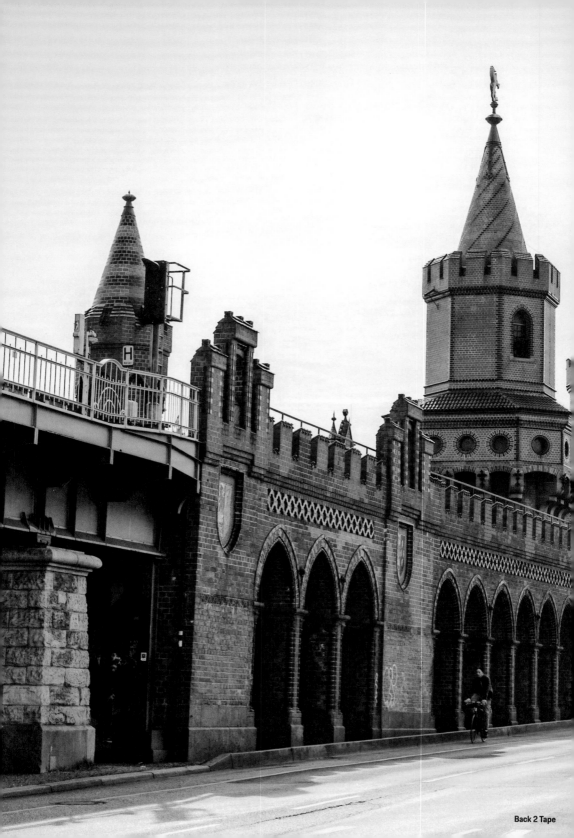

📍 **PLACES TO GO & DRIVE**

Overkill
Streetwear & sneaker store.
Köpenicker Straße 195a
10997 Berlin

Görlitzer Park
Meeting point for the local hip-hop scene
Between Wiener Straße and Görlitzer Straße.
U Görlitzer Bahnhof
10997 Berlin

Musik & Frieden
Nightclub and event location.
Falckensteinstraße 48
10997 Berlin

Mauerpark
Meeting place for street artists, street musicians,
music and antique enthusiasts.
Between Bernauer Straße and Gleimstraße
10437 Berlin

Teufelsberg
Former listening station, now a street art
attraction.
Teufelsseechaussee 10
14193 Berlin

RAW-Friedrichshain
Skate Hall Berlin, Club Cassiopeia.
Revaler Straße 99
10245 Berlin

Berlin 52° 31' 12" N 13° 24' 18" E

The feminist view.

Turkish bakery Melek Pastanesi, on Oranienstraße, is known as a local hub with long opening hours. You can sit outside at wooden tables and enjoy a coffee and cake, while pounding beats boom out of passing cars. In the fast-food shop next door, we meet Miriam Davoudvandi, who is one of the next generation of hip-hop activists in Berlin.

Davoudvandi moved to Berlin from the state of Baden-Württemberg. Her mother is of Romanian origin, her father is from Iran. In the South German province, hip-hop became a form of identity for her at an early age. She was particularly fascinated by the German-Turkish-Kurdish word art of rapper Haftbefehl, despite some gangster and macho attitudes. "You cannot get sexism and racism out of people as quickly as I would perhaps like," says the 28-year-old.

– "Rap must soften again" –

As a former editor-in-chief of *splash!* magazine, she has been, and remains, an important voice in a hip-hop world that is still male-dominated. "One day I am underway in a political activist context, the next in rap. The two are not mutually exclusive," the journalist believes. In her panel talk "I've got 99 problems, but being a feminist listening to rap ain't one", she and her colleague Lena Grehl discuss controversial issues from the scene – touching on debates that go way beyond hip-hop in the process.

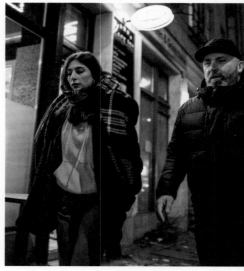

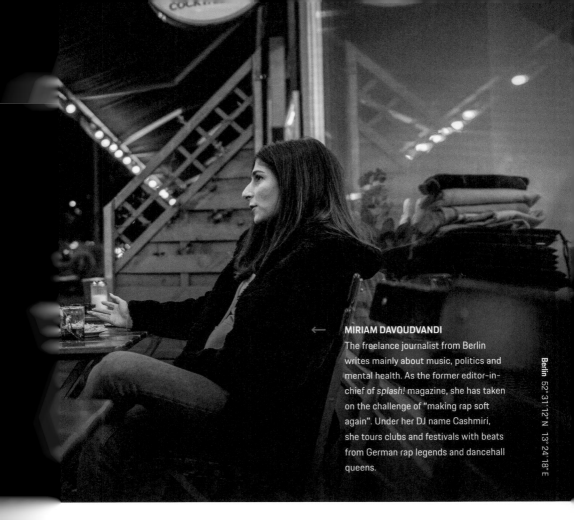

Berlin 52° 31′ 12″ N 13° 24′ 18″ E

MIRIAM DAVOUDVANDI

The freelance journalist from Berlin writes mainly about music, politics and mental health. As the former editor-in-chief of *splash!* magazine, she has taken on the challenge of "making rap soft again". Under her DJ name Cashmiri, she tours clubs and festivals with beats from German rap legends and dancehall queens.

With her DJ sets, under the pseudonym Cashmiri, she combines the journalistic perspective with musical practice. She implements her credo "Rap must become softer again" in her DJ sets, through diversity and a mixture of different genres. Songs from German rap legends now slot in somewhere between R'n'B heartache and dancehall queens. In the "Danke, gut" podcast, Davoudvandi has extended her spectrum into the field of mental health. Interviewing prominent guests, she talks about depression and mindfulness. At the same time, the online documentary series "Diffus Underground" also sees her present promising newcomers from Berlin, like Kasimir 1441, Şoho Bani and AOB.

The art of scratching.

Josi Miller also believes in new visions of the hip-hop culture. As a producer and DJ, she is striving to create her own musical signature. "There is always a scratch that you have not yet made," is her philosophy. On two self-financed turntables, she has mastered the noble art of putting down tracks on vinyl. In 2014, under the pseudonym YO-C, she finished runner-up in the 3style DJ competition. The joint tour with Trettmann in 2017 ensured that the Leipzig-born Berliner was known throughout Germany.

Josi Miller has been a hip-hop fan for as long as she can remember. However, as a youngster, she did not yet view it as culture. She simply enjoyed listening to the music with her friends – danceable, new, stylish, a way of life. That all changed the first time she held a record in her hand. She recognised an entire art form with

various facets. At the time, she could neither draw nor dance well. All she could do was put down tunes. And that was what captivated her.

She also manned the turntables for Berlin rapper Frauenarzt. Since 2016, she and Helen Feres have presented the podcast "Deine Homegirls", which is currently available on hip-hop channel BoomFM, on Berlin radio network Flux FM. "The more women occupy top positions, whether in the music industry or in line-ups, the less we need to discuss the topic," says Miller.

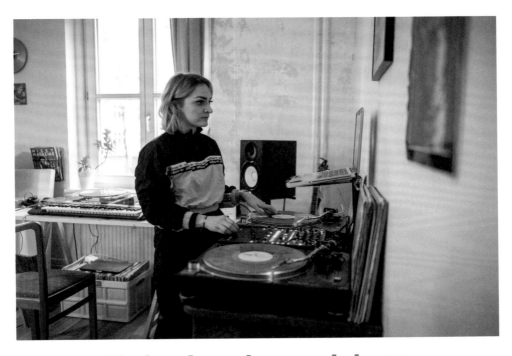

Berlin 52° 31' 12" N 13° 24' 18" E

– "It is already much better nowadays. However, I don't want to be booked for a festival just because I am a woman. In the end, it is the skills that count. That is what I want people to admire me for." –

that she has made a career of her hobby. Just as she appreciates the feeling that hip-hop gives her – as the culture has given her an "open view of the world". Nowadays, when Josi Miller passes a piece of graffiti in Berlin, hears the sound of basketballs on a public court, sees talented youngsters from the Flying Steps Academy dancing, or turns up a hip-hop song on the radio, she has the feeling of being a part of something bigger. Part of Berlin.

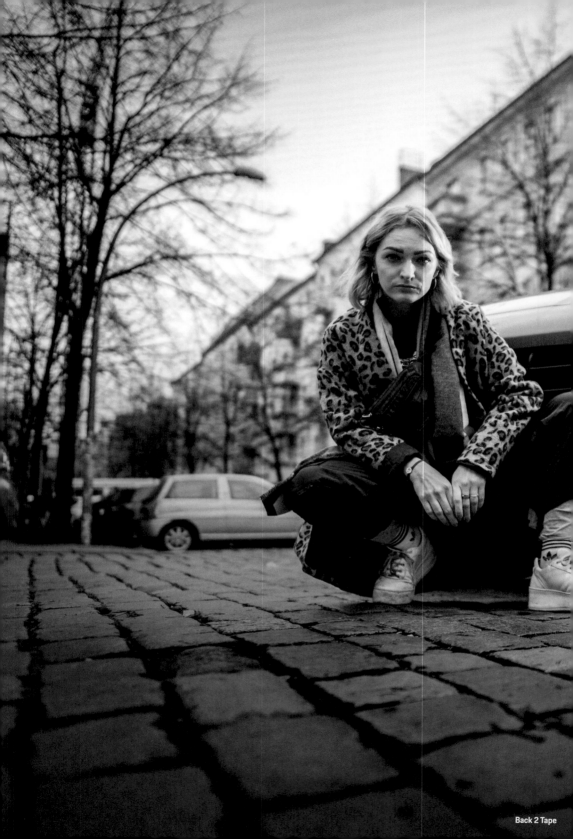

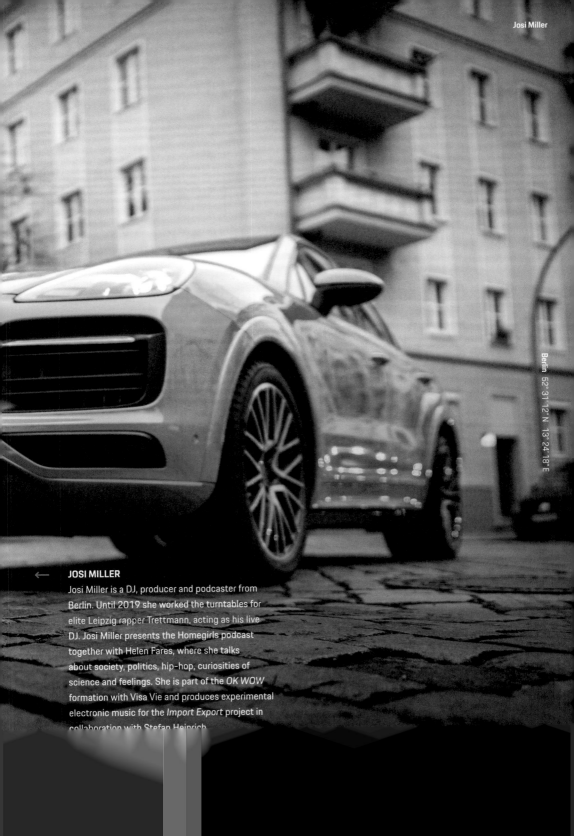

Berlin 52° 31' 12" N 13° 24' 18" E

JOSI MILLER

Josi Miller is a DJ, producer and podcaster from
Berlin. Until 2019 she worked the turntables for
elite Leipzig rapper Trettmann, acting as his live
DJ. Josi Miller presents the Homegirls podcast
together with Helen Fares, where she talks
about society, politics, hip-hop, curiosities of
science and feelings. She is part of the *OK WOW*
formation with Visa Vie and produces experimental
electronic music for the *Import Export* project in
collaboration with Stefan Heinrich.

Breaks and Bach

The *Flying Steps* from Berlin are probably the best-known breakdance crew in the world. Their message: continuous development and respect for the history of hip-hop. Artist, manager and *Back 2 Tape* guest Michael "Mikel" Rosemann talks about how it all started at the youth centre and turned into a sold-out US tour.

Where do your hip-hop roots lead?

Michael "Mikel" Rosemann: to a housing estate in Berlin-Moabit. At the end of the eighties, our group of teenagers spent a lot of time copying what we saw on *Yo! MTV Raps*. We wanted to be cool, playing records and beatboxing. I first saw the style with tracksuits and Adidas Superstars in the video with *Run-D.M.C.* Rapping or mixing wasn't my thing, so I picked up a sketch book and had a go at graffiti. I never reached perfection but still consider it as a passion. And then the dancing started. Although I was quite shy, the culture of breakdance just grabbed me.

At that time, how would you describe the atmosphere in Berlin?

MR: There was at least one gang in each district. The *Bulldogs* claimed Moabit, while the *36 Boys* ruled in Kreuzberg. There were turf wars and you had to be very vigilant about where you put your tags. After the collapse of the Berlin Wall the *SWAT-Posse* from East Berlin came along, merging rap and breakdance. The first time I met talents from all over Germany was at a jam in Adlershof. These included the breakdancer Storm, who had already gained international experience. Rapper Torch and MC Rene were there too. You could sense a wind of change.

Did the *Flying Steps* evolve from that?

MR: In the beginning, it was a family atmosphere and everybody was united. This musical area developed rapidly after the first successful performances of rap in German. But there were no structures in place for breakdance. The breakers formed crews in order to train together. At the beginning I had my own group, but then Steps founder, Kadir "Amigo" Memis, asked me to join his crew in 1994. That was pretty much when the *Flying Steps* were born.

How did breakdance became your primary focus in life?

MR: We wanted to develop and create our own style. Popping, locking, footworking and the spectacular power moves already existed. That all found expression at the jams. Sometimes you could win prize money, but that only just covered the travel expenses. Then street culture became a big thing. Events like streetball tours took place, combining basketball and hip-hop. After we'd been paid a few times, we noticed: this has potential! Nonetheless, I completed an apprenticeship as a screen printer after I finished school. No one really imagined that you could make a living with breakdance. The Flying Steps had already performed outside Germany. Unfortunately, my boss at that time would not

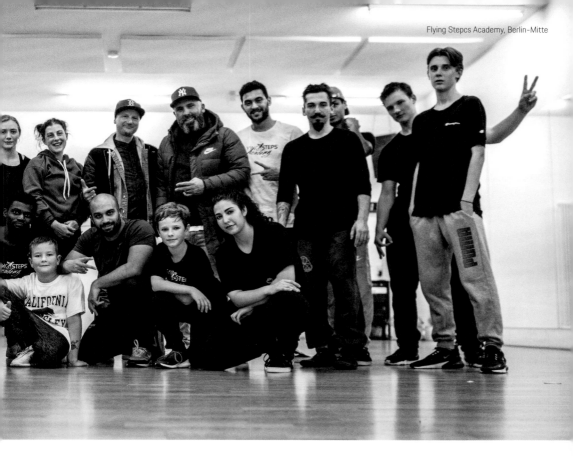

grant me extra holidays. The boys came back with pictures and videos. Back then, we had to send out VHS tapes to raise more awareness.

Hip-hop changed dramatically over the course of the nineties and in the first decade of the new millennium. How did you cope with the new influences?

MR: We did not want to stick with the old school. These new sounds inspired us to develop further. Sometime in the nineties, house dance emerged with its fast step combinations. Without those classic toprocks, this style grooved into another direction. You could combine some of those elements with the breakdance programme. If we wanted to tell our own story, we had to open up to these elements. We did not want to be mere background performers.

What helped you stick together over the years?

MR: The shared idea and a healthy dose of self-confidence. Until the 2000s we were training every day at youth centres, like "Zille" in Charlottenburg. There were ups and downs. We had already performed at fairs, shows and gala events. And, from 2004 onwards, there were already internationally organized competitions like *Battle of The Year* or the *BC One*. On these occasions, we were able to meet dancers from around the globe. I started sharing my knowledge with the kids in the youth centres. This is one of the founding ideas of the Flying Steps Academy.

Are you comfortable with the old-fashioned term "dance school" to describe your Academy?

MR: Call it what you like (laughs). In addition to techniques, we also like to focus on values and

the history and culture of breakdancing. Not all the kids are up for that. But this is not a problem. At that time, I also just wanted to start dancing. I started dancing listening to funk tracks by James Brown, without knowing anything about him. It was only much later that I noticed JB samples in dozens of hip-hop songs. This shows how you can learn all about a culture via the music. We teach this in a lot of our workshops. We like to think outside the box. For example, with breakdancers from France who have their own styles. Our pupils are always really surprised by that. We also show them legendary films like *Breaking* and *Beat Street*.

For a long time, breakdance was dominated by male dancers. Have you noticed any change in the numbers of break girls?

MR: In the meantime, the B-Girl community has grown substantially. In 2024 there will even be a B-Girl battle at the Olympic Games in Paris. The music and the circumstances have changed. I can still remember the atmosphere in the youth centres. A room filled with the smell of sweat and booming hip-hop beats. Of course, that sounds appalling. Nowadays, there are a lot of urban dance styles and many B-Boys actively connect with and support the girls.

← ***FLYING STEPS***

The Flying Steps are a dance group from Berlin that specialize in breakdancing, popping and locking and are rooted in international hip-hop culture. The crew was founded in 1993 by Kadir "Amigo" Memis and Vartan Bassil, today they run the largest urban dance school in Germany with 35 teachers, 20 different dance styles and more than 1,800 students. In 2010 the presented the "Red Bull Flying Bach" dance performance under the artistic direction of Christoph Hagel, performing breakdance and contemporary dance to the sound of the *Well-Tempered Clavier* by Johann Sebastian Bach.

You have become globally renowned for your spectacular shows, like "Flying Bach" and "Flying Illusions". Knowing that classical music is quite different from hip-hop...

MR: That's right, but that's exactly what it's all about. Vartan watched a classical performance and then came back with the idea of replacing the ballerina with a breakdancer. We had already started with choreographies and stage sets, dancing with basketballs, and performing in a living room scenario, dancing across tables and chairs. We have no reason to feel that we are not on the same level as classic dance ensembles.

Then we discovered the opera director Christoph Hagel, a professional who speaks our language. The producers translated the music of Johann Sebastian Bach into our style — and even managed to use the beats. Two worlds collided and it worked out great! I have been working with this new style for ten years. Now and then, I still get back on stage, although I officially retired in 2015. I thoroughly enjoy these shows and I guess I just cannot stop participating. Once a dancer, always a dancer.

Ams
ter
dam.

Amsterdam 52° 22' N 04° 54' E

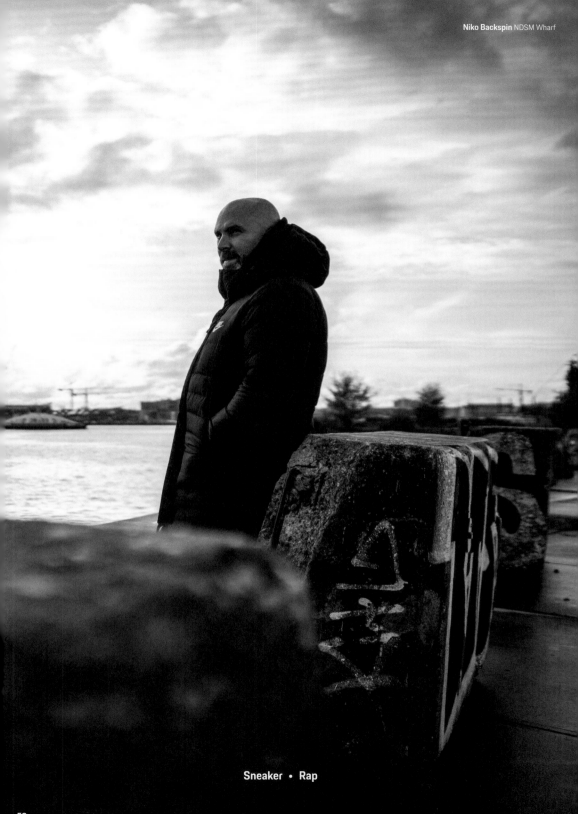

Sneaker • Rap

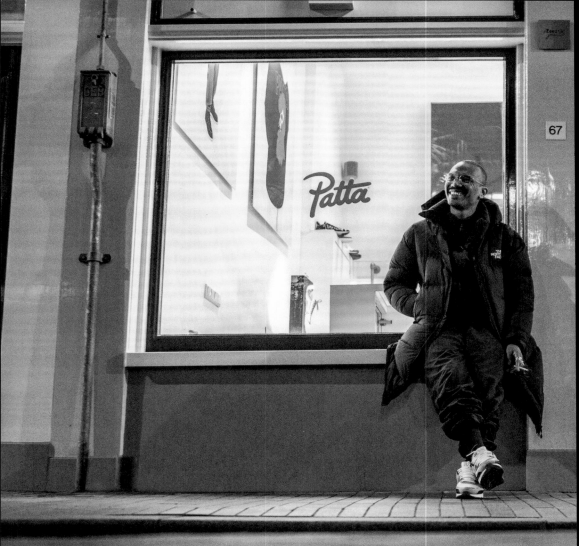

ON LIGHT SOLES

Amsterdam 52° 22' N 04° 54' E

In the past, when it came to the creative pulse of Europe, the beat of the Dutch metropolis was often insignificant compared to aspirational neighbours like the German capital and Copenhagen. However, that is a thing of the past. The famous canals are still as idyllic as ever, but in many districts — from the industrial north to the fashionable south — there is a sense of a city constantly striving to reinvent itself. And succeeding.

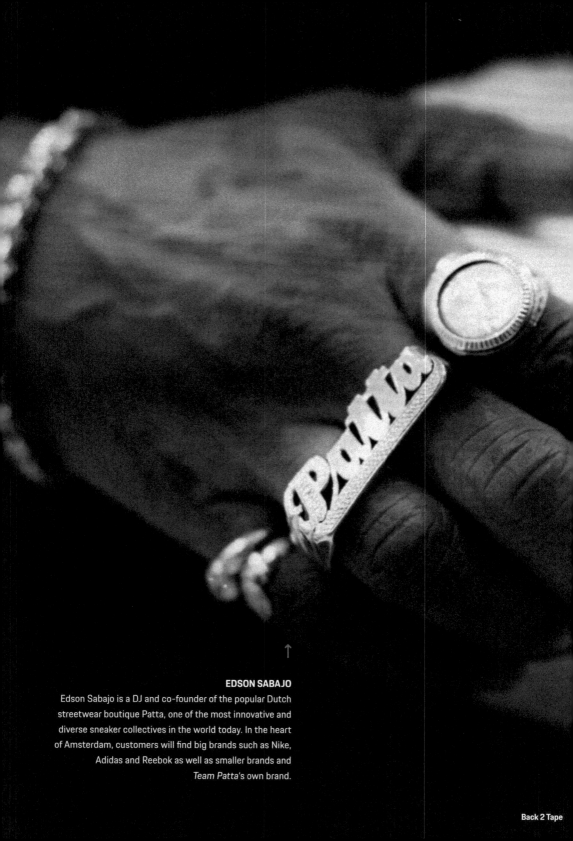

↑

EDSON SABAJO

Edson Sabajo is a DJ and co-founder of the popular Dutch
streetwear boutique Patta, one of the most innovative and
diverse sneaker collectives in the world today. In the heart
of Amsterdam, customers will find big brands such as Nike,
Adidas and Reebok as well as smaller brands and
Team Patta's own brand.

Amsterdam is now one of the most creative hot spots in Europe. The urban style of the Dutch metropolis is shaped by life on the waterfront, the influence of many different cultures, a vibrant nightlife, and far more bicycles than there are inhabitants. On the European map, Amsterdam is no longer an insider tip. Instead, it has become a must see for anyone who wants to feel the diversity, vibe and creativity of the continent in one place.

Two people who have helped shape the city's attitude to life for many years are Pete Philly and Edson Sabajo. They are guests on our *Back 2 Tape* journey, on the trail of hip-hop and cultural diversity in Europe – and their city is, after Berlin, the first point of call on our roadtrip in the Porsche Cayenne S Coupé. Edson and Pete are familiar faces on a scene that has far more influences than the four classic elements of hip-hop. They are proof of how something new and unique can emerge from a cultural mosaic.

Edson Sabajo is a DJ, former MC and co-founder of the world's first sneaker collective, *Team Patta*. Together with his current business partner Guillaume "Gee" Schmidt, they regularly visited the USA in the 90s, in order to soak up the local scene there. He recalls: "In New York there have always been multi-cultural districts, like the Bronx. That has definitely had an influence on me. Still, to this day," says Sabajo with an American accent and a charming grin never far from his lips.

"Then Amsterdam hip-hop started to take its first breaths. We were still listening to Madonna or *Cool & the Gang*, and suddenly there was this different beat. We were immediately bitten by the bug," says Sabajo.

Amsterdam 52° 22' N 04° 54' E

International influences define Dutch hip-hop culture.

– "Before long, we were an established community. Here, nothing was segmented – whether graffiti, DJing or rap. There was simply everything. And everyone gave everything a go. Even me." –

Sabajo started out as an MC, but without any significant success. His voice was too weak, his beats too middle-of-the-road. "However, I always wanted to stick with hip-hop."

A weakness for sneakers from around the world
And so it was that Edson Sabajo discovered his talent behind the mixing deck and became a successful DJ. Amsterdam's legendary radio show Villa 65 Dutch Masters distributed Edson's first mix tape. This was followed by his own radio show at HipHop 120 – the foundation for his career had been laid. Edson soon found his second passion: "My early period was particularly influential for me. With my music, I was always surrounded by clothes. And I have always had a weakness for cool sneakers! The trips to America, the Eldorado of sneakers, did not improve matters," Sabajo recalls, chuckling. The right outfit plays an important role in the life of a hip-hopper. Fashion and fame go hand in hand. As with sport, a certain dynamic, rhythm, and a good portion of coolness are essential in hip-hop, and they are exemplified by the characters on the scene. It goes without saying that getting the right sneaker is just one step away. Whether Nike Air Force One or Puma Suede: it is cool to be special.

"When we returned to Amsterdam, we literally used to have the hottest material on our feet," recalls the hip-hop DJ with an obsession for sneakers. "My buddy Gee and I soon turned it into a business. And here I am today, in our own store. That's cool, isn't it?" says Sabajo proudly, and totally immodestly. Patta is located in the heart of Amsterdam and is just a stone's throw from the Rembrandt House Museum and Anne Frank's house. Just two of many attractions in close proximity in the historic district, flanked by the canal network to its west. This Amsterdam grid square has not been sullied by a single centimetre of new concrete and is in remarkably good condition. And, admittedly, we parked the Porsche for a short while – you can simply be more mobile on foot or bike here.

The two founders of *Team Patta* have rejected a possible link with franchise companies, which would have earned them a lot of money.

– "We want to remain independent, not to belong to any old chain. We are well established on the scene and it is important to stay real – in business as well as in hip-hop!" –

Consumption details
Porsche Cayenne S Coupé (as of 3/2021)
Fuel consumption, urban: 12.8 l/100 km
extra-urban: 8.2 – 7.9 l/100 km
combined: 9.9 – 9.7 l/100 km
CO_2 emissions combined: 225 – 222 g/km

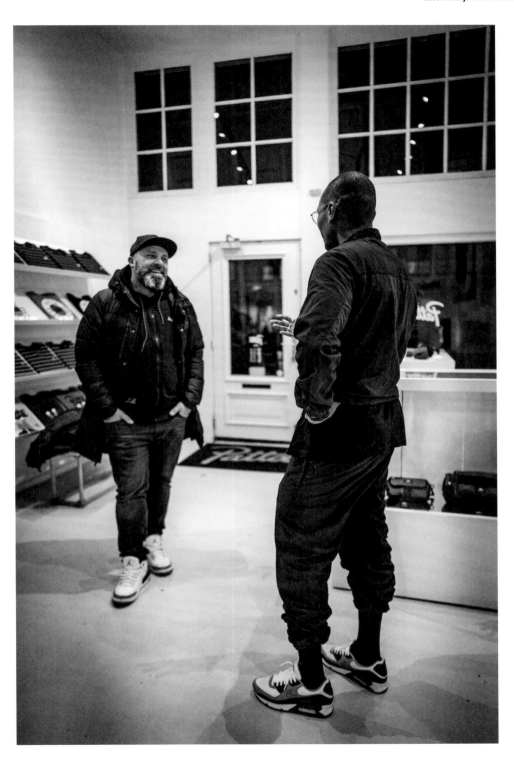

– "Hip-hop has opened my heart" –

Like Edson Sabajo's sneaker store, Pete Philly is an authority on the Amsterdam hip-hop scene. In his home of Aruba, one of the Caribbean islands belonging to the Netherlands, he came into contact with music early on. "I was musical from an early age. I listened to songs inspired by funk: Michael Jackson, Prince ... When I was just four years old, I dragged my father into the local record store and was desperate to get my hands on Jackson's new album Thriller," Philly explains. "There was finally something that we blacks could identify with and that gave us stability. I just thought, oh yes, this is my home," says Pieter Monzon, to use his real name. When the 1989 song Me, Myself and I was released by De La Soul, it was all over for Pete Philly. The groove, lightness and, above all, the level of rap lyrics and self-empowerment still shape him as a musician to this day. "Hip-hop has opened my heart," says the Dutch MC, who has toured with superstar Kanye West and funk legend James Brown.

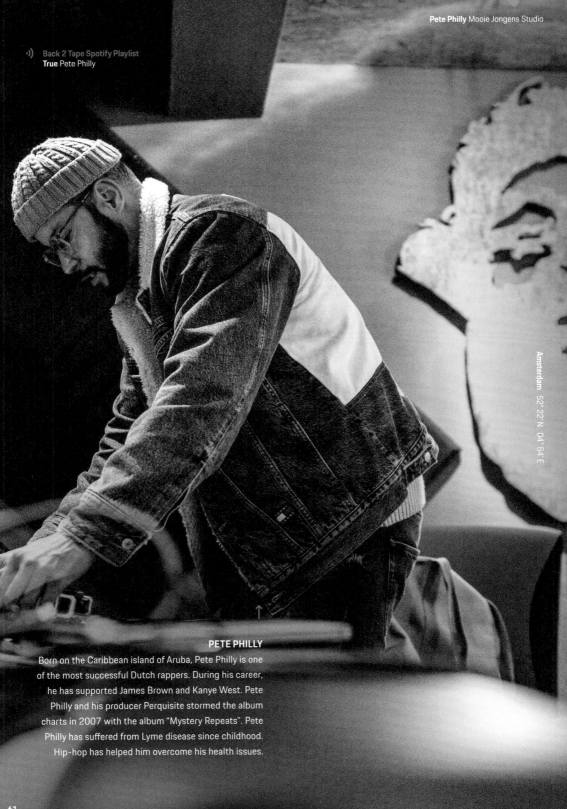

Back 2 Tape Spotify Playlist
True Pete Philly

Amsterdam 52° 22' N 04° 54' E

PETE PHILLY

Born on the Caribbean island of Aruba, Pete Philly is one
of the most successful Dutch rappers. During his career,
he has supported James Brown and Kanye West. Pete
Philly and his producer Perquisite stormed the album
charts in 2007 with the album "Mystery Repeats". Pete
Philly has suffered from Lyme disease since childhood.
Hip-hop has helped him overcome his health issues.

Hip-hop is about constantly reinventing oneself.

He started rapping in English at the age of just 14. Pete Philly found that this language better reflected his ambition for poetry than Dutch. In doing so, he broke new ground in the Netherlands, and became a respected figure on the scene.

"Fortunately, hip-hop is always reinventing itself. What other music genre can claim that? Jazz, perhaps? No way. Hip-hop has always been there for the youth for forty years, and has lived through entire generations," says Philly. "It will never stop being fresh and new. That is really important for future hip-hoppers. It is not about how something has to sound, but about priorities: do I really need to make this track? What am I trying to say with it?" Philly continues. He cuts straight to the truth of hip-hop, and is credible. He gives hope to many on the scene.

Hip-hop as motivator
Pete Philly returned to the scene in 2019 after a break of several years. Lyme disease, which is usually transmitted via tick bites, had put a spanner in the works after several successful years, and thrown his partnership with producer Perquisite off course.

– "But the music cured me," –

Philly is sure of that. Seven years after his last album "One", he returned to the public eye with new music. Today, we hear his beats in the studio and know that he has reinvented himself again. The fact that fans still appreciate his art, which is somewhere between funk, rap, soul and R 'n' B, was proven by the concert to mark the release of his EP "Lift". More than 15,000 people danced to the beat of Pete Philly – on light soles in creative Amsterdam.

Amsterdam 52° 22' N 04° 54' E

⚲ PLACES TO GO & DRIVE

Club Bitterzoet
Nightclub and event location.
Spuistraat 2 HS
1012 TS Amsterdam

Café de Duivel
Legendary hip-hop bar.
Reguliersdwarsstraat 87
1017 BK Amsterdam

Waxwell Records
Record store for old-school rap and Dutch beats.
Gasthuismolensteeg 8 a
1016 AN Amsterdam

Zeedijk 60
Streetwear & sneaker store.
Zeedijk 60
1012 BA Amsterdam

NDSM
Former shipyard, now a creative centre and graffiti gallery.
NDSM-Plein 28
1033 WB Amsterdam

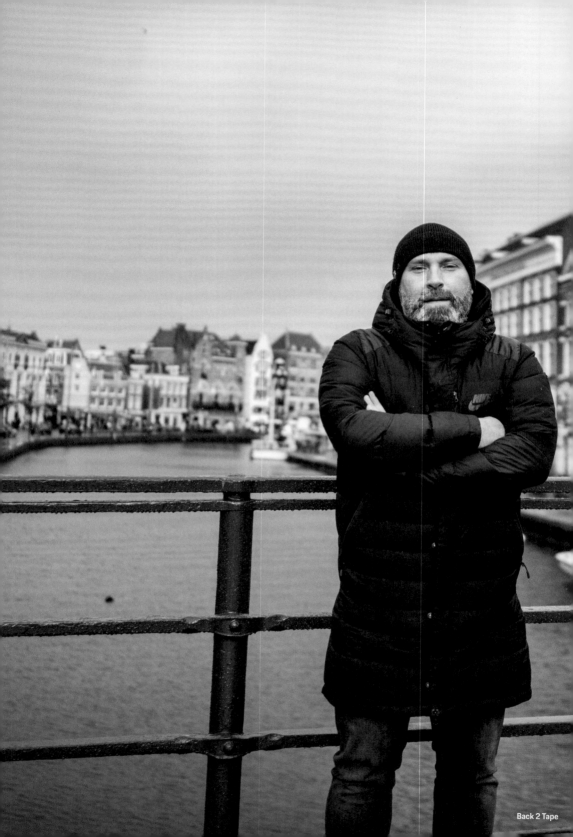

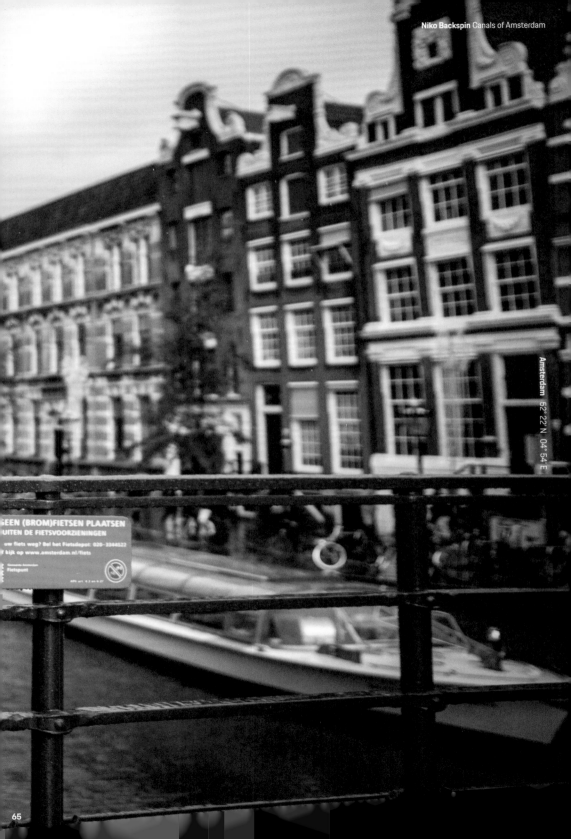

Amsterdam 52° 22' N 04° 54' E

GEEN (BROM)FIETSEN PLAATSEN
BUITEN DE FIETSVOORZIENINGEN

uw fiets weg? Bel het Fietsdepot: 020-3344522
bijk op www.amsterdam.nl/fiets

Gemeente Amsterdam
Fietspunt

Fashion & Fame

Few subcultures have shaped fashion in the 2000s as powerfully and as enduringly as hip-hop. Even the major fashion labels are unable to escape this dynamic, drawing inspiration from the mix of styles of artists around the world.

One day, back in the early 1990s, Tommy Hilfiger was strolling through John F. Kennedy International Airport in New York City with his brother, Andy, when he spotted an African American dressed head-to-toe in Hilfiger. It was Grand Puba from hip-hop group, Brand Nubians on his way to a gig. Seeing Puba in XXL gear accessorised with Air Force 1s and a heavy gold chain gave Hilfiger an idea. He sent brother Andy to Harlem, the Bronx and Brooklyn to sell Hilfiger fashion to the hip-hop community from the boot of his car. Tommy, who had been designing leisure attire for conventional white preppies, doubled his turnover in the space of a year.

Hip-hop and fashion – the perfect pairing.

The affinity between hip-hop and fashion is no coincidence – style has always been a core aspect of identity on the hip-hop scene. In 1980s New York, for instance, it was often possible to tell the neighbourhood a person came from, based on their shoes or the brand of clothing they wore – and how they combined them. Colours and brands had to correspond. The fit had to be "flashy and fly".

Then there are the persistent, typical brand loyalties of specific subcultures. The brands function like codes, which the brands then use to their benefit to raise their profile in pop culture. Simply put, anyone wearing Cazal 607 glasses, Superstars and a Kangol wants to state their allegiance to 1980s New York hip-hop. They don't even have to know much about it; these three badges are all it takes to be recognised as a kindred spirit. Hip-hop fans didn't just adapt luxury brands; they also incorporated aspects of life in the 'hood. On the west coast, folks quickly began wearing low-hanging "baggy pants" and white T-shirts – a style synonymous with prisons, where belts weren't permitted. This was paired with white T-shirts because blue and red, usually displayed on a bandana, could indicate membership of a specific gang. In New York, you at least had a choice between shoes and glasses or your life. Cazal 607s and Nike Jordan 1s were the first branded items to cost lives.

Lisa Rauh, rap aficionada and senior designer at Adidas, says: "Brand allegiance is now in its second or third generation, so it can't be a phase. A brand has its highs and lows, but the older a brand gets, the more valuable its heritage and the more established it becomes. Even smaller brands like Stussy, which turned forty last year, are still hot and attracting new generations." These are trends born on the street, not on the catwalk.

Who will spark the next big thing?

The origins of some trends are still very much about inventiveness and circumstance. The fashion adaptation of various outdoor brands like North Face, Columbia and Helly Hansen arose purely from the fact that the streets of New York and Chicago can be bitterly cold in winter, and people went in search of good-looking clothes that offered some degree of protection from the elements. The bold colours of sailing and outdoor fashions fit the bill, so when the weather turned cooler, they donned nautical clothing and cruised the neighbourhood in open-top Jeeps. The brands weren't long in responding – they launched countless colourways and variants, outdoor brands established "street departments". In 2020, North Face announced a collaboration with Gucci. Three years earlier, the luxury brand had opened a studio with legendary designer Dapper Dan.

Dapper Dan is a supernova of hip-hop fashion. He opened his legendary Taylor Store on 125th Street in Harlem in the early 1980s, where he crafted his versions of branded streetwear. He often used original fabrics and materials from Gucci, Louis Vuitton and Fendi, especially those normally used for luggage – only, he used them to make tracksuits. The collections were massive hits. He was soon dressing all the big-name rappers, until it all got too much for the luxury labels and they shut him down. The collaboration came two decades later.

The connection between fashion and rap took an interesting turn with Kanye West and Virgil Abloh, both often highly praised for their style. After West was initially touted as a possible creative director for Louis Vuitton, it was Abloh, Kanye West's former artistic director, who ultimately got the job. Kanye West retaliated with the design of the Yeezy sneaker, which became a huge bestseller for Adidas.

Contemporary style icons.

Rap artists are contemporary style icons, with two in particular standing out for Lisa Rauh from Adidas:

– **"Pharrell Williams and Beyoncé – because they bring their hip-hop roots into their outfits in an authentic way without resorting to cliches. It creates unexpected looks and sets trends as a result."** –

Other stars dive straight in and establish their own fashion labels. Rihanna has a successful range of lingerie and sunglasses (Savage X, Fenty), while Missy, Lizzo and co. are celebrated as style icons. The high-fashion industry knows this, and is orienting itself towards it more and more. Feminism is being celebrated not only in terms of content but also visually. However, the world first has to learn how to celebrate self-empowerment. Self-confident female rappers have long been misunderstood – too sexy, too scantily clad, saying "bitch" too often. But usually, it was these women who were also taking entrepreneurship and creativity way beyond their music. The next wave is already waiting in the wings – rappers like Noname from Chicago represent a new generation of role models for diversity in hip-hop culture.

Grills worn by superstars
French designer Dolly Cohen specialised in an accessory that initially found its way into hip-hop culture via pimps and gangsters. Known as grills, they are permanent or removable items of jewellery for the teeth, made from gold or platinum. Gold teeth are a status symbol in the Caribbean, and the trend made its way from there into the USA, where grills took off in the mid-90s, especially in the southern states. 20 years later in Paris, Dolly Cohen specialised in fashionable, more intricate and highly artistic grills, and the high-fashion scene seized upon it. It surely helped that Cara Delevinge wore one of the very first Cohen grills, followed by reality star and entrepreneur Kim Kardashian. Givenchy hired Dolly to make grills for catwalk models. Dolly Cohen now has a practice in Beverly Hills. Hip-hop and fashion are a perfect match, because the culture works like the fashion industry – it has to constantly reinvent itself in order to survive. Creative expectations remain high, just like the surprises that come from who or what sparks the next big hype.

Bar celo na.

Barcelona 41° 23' N 02° 11' E

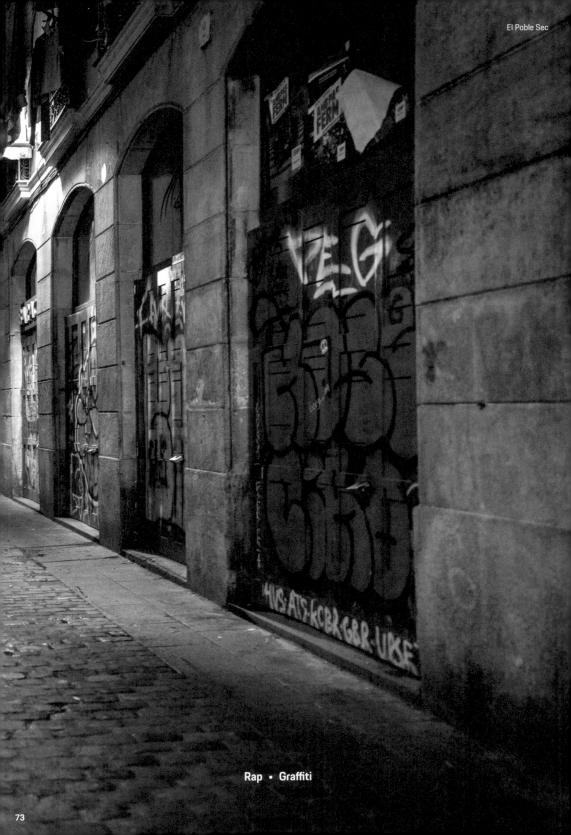

Rap • Graffiti

FALSALARMA
Falsalarma, consisting of MCs David & Ángel
Navarro Romero (aka El Santo & Titó), DJ Neas
and Dycache Santiago, come from Sabadell,
an industrial city northwest of Barcelona. The
rap crew has been a permanent fixture in the
Spanish hip-hop scene since 2005. They rap
about resistance to domestic violence and are
active campaigners for social initiatives in their
neighborhood.

BETWEEN HEAVEN AND HELL

Barcelona is tattooed. Previously, there were around 2,000 graffiti artists here, now there are ten times more. As such, it is worth taking a closer look to discover the street art that is hidden on each corner. Alongside the very lively cultural and musical scene, you find all those fantastic sights like the Sagrada Familia or the modernist Casa Batlló, constructed by Gaudí. On top of that, there is the ideal location on the Mediterranean and the mild climate — who could resist that?

Rap from the streets, beats against domestic violence.

♀ **PLACES TO GO & DRIVE**

El Raval

Museum of contemporary art.
Rambla de Raval
08001 Barcelona

Razzmatazz

Nightclub and event location.
Carrer dels Almogàvers, 122
08018 Barcelona

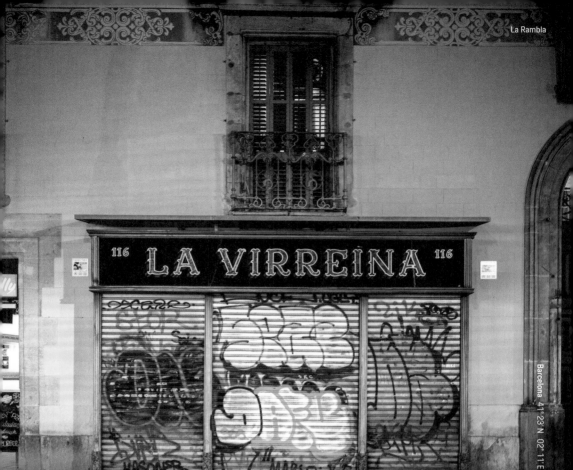

We are heading towards the north of Barcelona – on the trail of rap crew *Falsalarma*. Starting at the sea, our Porsche Cayenne Coupé carries us over the gentle hills of the Serra del Collserola. This place is known as the "green lung" of the Catalan city. Numerous racing cyclists swarm around the region on a weekend to escape the busy city life – and to conquer the altitude. We could have driven on the motorway and easily arrived half an hour earlier, but we wanted to take a detour. The beautiful views, the impressive curves. Towards a quarter far less picturesque and a quartet that could not be more different. This is also an integral part of what makes Barcelona.

"Welcome to our dirty cellar," is how El Santo greets us with a twinkle in his eye at the Placa Le Termes in Sabadell. *Falsalarma* is the crew of MCs David & Ángel Navarro Romero (also known as El Santo & Titó), DJ Neas and Dycache Santiago. They are all from Sabadell, an industrial town in the north-west of Barcelona. The four artists have deep roots in this neighbourhood, and not just because their studio is located underground, in a cellar.

"This is where we created our first tracks. We recorded Alquimia here in 2005 – our second album that went viral shortly after its release." The songs of the Spanish artists focus on matters like resistance to domestic violence, among other things. This is a topic that is very real in their neighbourhood.

Different approaches, a common goal.

The four hip-hop performers today define themselves clearly as *Falsalarma* but have very different approaches. "We just tried everything and enhanced our profile. It didn't matter if we attended battles in tagging, skating or breakdance. At some point, I started to text and to rhyme and in between that I was scratching vinyl too. Then back to texting. Like a baby starting to walk," explains Titó. "Friends who listened to us by pure chance went bananas with joy. At some point they all said 'Mate, you should do that full-time – it is really great'," remembers Titó.

On the other hand, crew member DJ Neas recalls very well how he discovered breakdance:

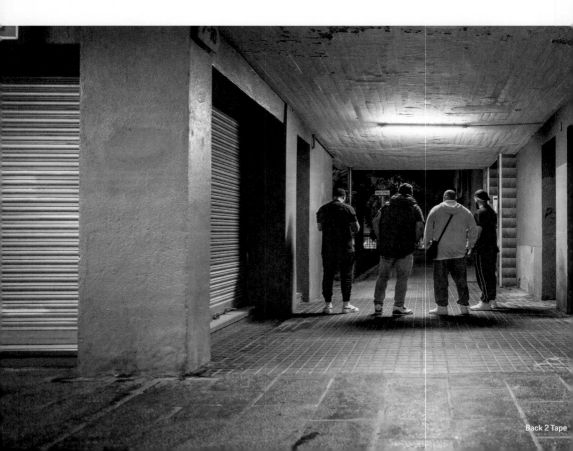

•)) Back 2 Tape Spotify Playlist
Mi Peor Enemigo Falsalarma feat. Nach

— "I was still at primary school, around 1993. Somewhere a few boys had built a rectangular parcours out of parquet flooring, switched on the tape recorder and started to dance. That still fascinates me to this day." —

But for all of them, one thing is the same: whether it is breakdance, tagging or graffiti, each form is a dialogue with the street itself. A dialogue that pays no attention to where you come from. The main thing is to do it with enough passion and for the right reason.

Away from the rough north, we continue our journey to the centre of Barcelona. That is where life is pulsating. This time, we do take the motorway. The Mediterranean shimmers on the horizon and the silhouette literally clings to the bonnet of our Porsche Cayenne. What a sublime landscape. We reach the city quickly. Our next destination is located between the El Poble quarter and the emerging district of San Antoni. There are creative tapas bars as well as the famous street full of theatres celebrating performing arts. The other district is characterised by cosy street cafes, small oases of peace for families, and a popular weekly market. At Carré de Salva 10, we discover a recently staged collaboration: graffiti art accessible to all. In the "Negrelab" anybody can grab a spray can. The creative mind behind this project is El Xupet Negre.

Barcelona 41° 23' N 02° 11' E

Sabadell

Consumption details
Porsche Cayenne S Coupé (as of 3/2021)
Fuel consumption, urban: 12.8 l/100 km
extra-urban: 8.2 – 7.9 l/100 km
combined: 9.9 – 9.7 l/100 km
CO_2 emissions combined: 225 – 222 g/km

Back 2 Tape

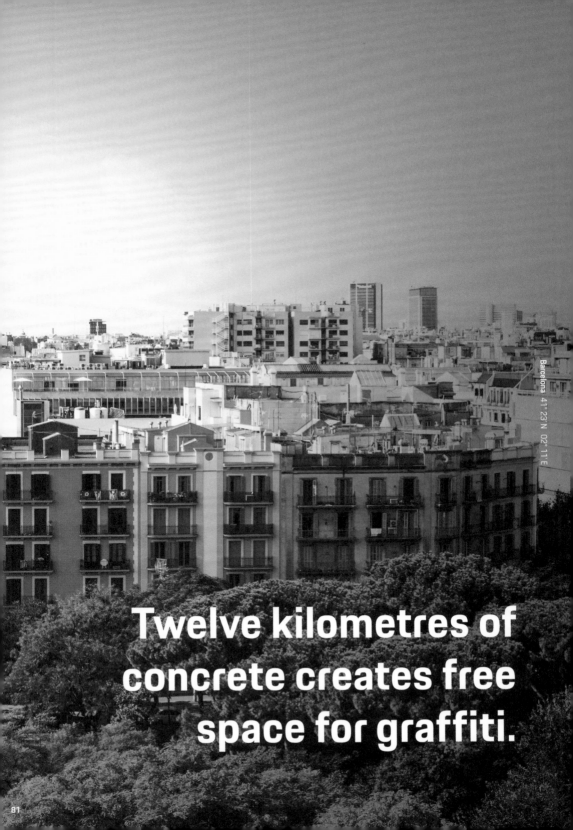

Twelve kilometres of concrete creates free space for graffiti.

Barcelona 41° 23' N 02° 11' E

The black dummy, his trademark, is just as much a part of Barcelona as the green turf is a part of the Camp Nou. At least for those who stroll through the streets of that Spanish coastal city and are fascinated by graffiti and urban art. It was in 1987 when the symbol, created by trained graphic designer El Xupet Negre, emerged for the first time. To this day, he remains legendary for graffiti in Europe.

Long before hip-hop became relevant and crucial to Spanish youth culture, the artist roamed the streets with marker pens and spray paint.

— "At the time, it was not easy to express a certain degree of creativity. Anything that was different was prohibited." —

The graffiti pioneer developed an enthusiasm for painting at an early age. People admired his drawings and advised him to create his own logo. But the first time he drew his black dummy, he was caught by the Guardia Civil: "The city reacted vigorously and handed out some fines." Today, El Xupet Negre is one of the 50 most influential street artists in the world. He sells swimsuits, hoodies, caps, t-shirts and limited-edition posters in his own shop, but also offers wooden handicrafts — even painting with a government contract.

Twelve kilometres of concrete creates free space for graffiti

The situation for free street art changed in Barcelona with the parliamentary elections in 2012. A degree of autonomy returned. El Xupet Negre is inspired by family, art history, graphic design, brands, street signs and pop art. He paints on walls officially provided by the city of Barcelona. "In the past there were maybe around 2,000 graffiti artists in Barcelona, now there are nearly 20,000 of us," explains Xupet. "We established a designated website, on which any sprayer can register and reserve a piece of blank wall." The city provides a canvas on a wall of more than twelve kilometres, where sprayers can play around with any form of graffiti.

Back 2 Tape also has a piece of blank concrete wall. In the midst of the prestigious residential area of El Poble-Sec, there is now a piece of freedom for the youth of the city: a real paradise for skaters and graffiti artists that now depicts a specially created Back 2 Tape logo next to the famous black dummy from El Xupet Negre. As Xupet puts the spray can aside and looks up into the sun-drenched Spanish sky, he waxes philosophical: "Nowadays, Mozart would not play the piano. He would be scratching vinyl. And Leonardo da Vinci would not paint on canvas made of fabric, but of concrete." Well, Xupet is spot on.

A trademark black dummy.

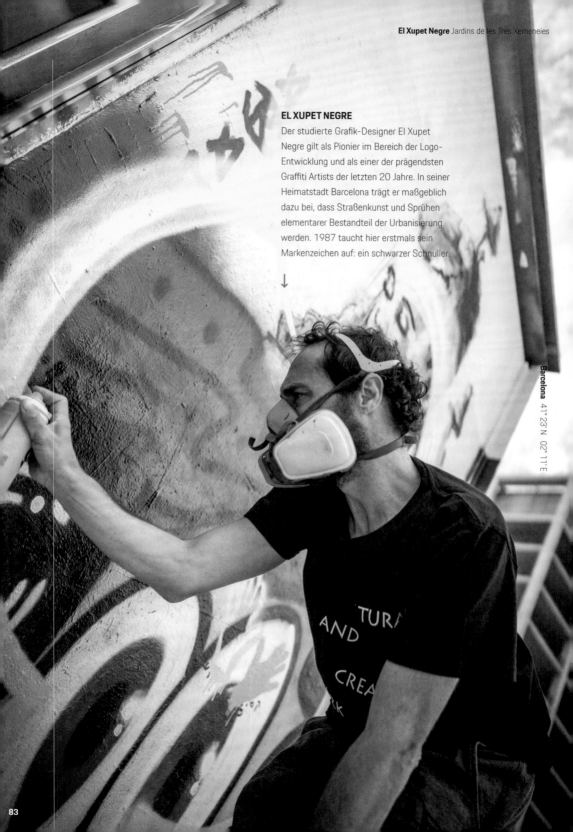

EL XUPET NEGRE

Der studierte Grafik-Designer El Xupet
Negre gilt als Pionier im Bereich der Logo-
Entwicklung und als einer der prägendsten
Graffiti Artists der letzten 20 Jahre. In seiner
Heimatstadt Barcelona trägt er maßgeblich
dazu bei, dass Straßenkunst und Sprühen
elementarer Bestandteil der Urbanisierung
werden. 1987 taucht hier erstmals sein
Markenzeichen auf: ein schwarzer Schnuller.

↓

Barcelona 41° 23' N 02° 11' E

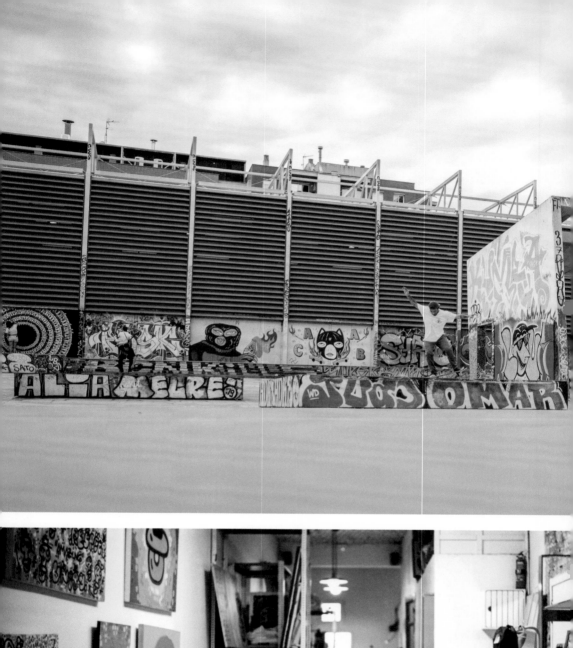

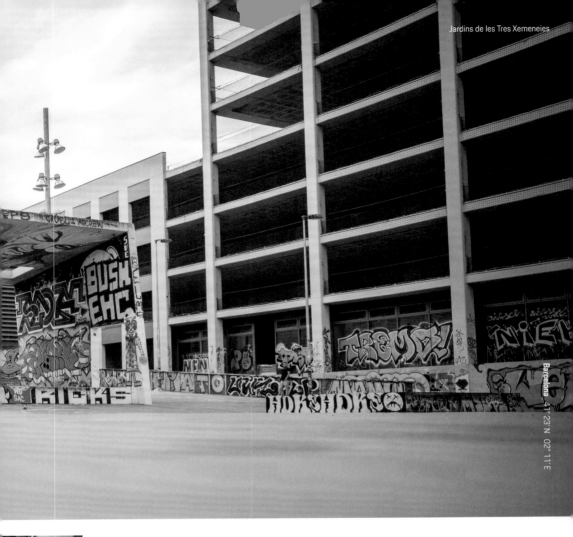

Barcelona 41° 23' N 02° 11' E

⚲ PLACES TO GO & DRIVE

Jardins de les Tres Xemeneies
Popular park for skaters.
Av. del Paral·lel, 49
08004 Barcelona

Collserola Natural Park
Nature park with integrated graffiti gallery..
Collserola Ctra. de l'Església, 92
08017 Barcelona

Mercat de San Antoni
Market hall with street food and regional delicacies.
Carrer del Comte d'Urgell, 1
08011 Barcelona

Jamboree
Legendary jazz club and concert hall.
Plaça Reial, 17
08002 Barcelona

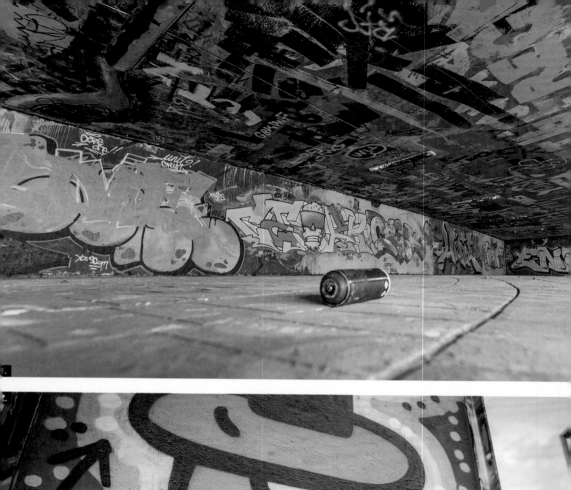

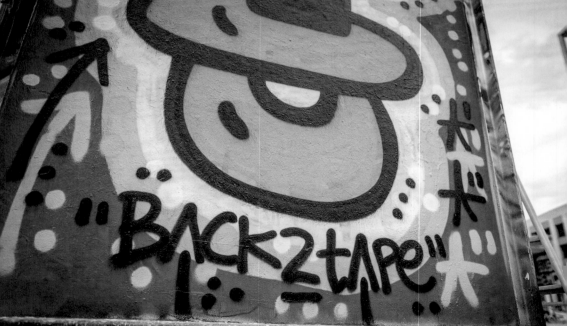

1. **STUTTGART** Hall of Fame Bad Cannstatt – **Unknown artist**
2. **BARCELONA** Gardens of the three chimneys – **El Xupet Negre**

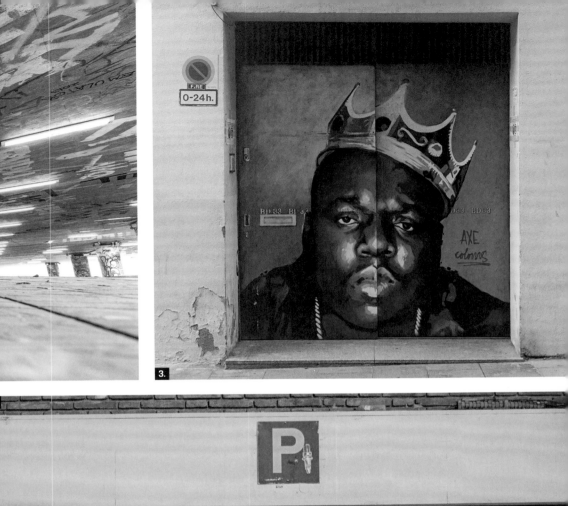

3. **BARCELONA** Unknown location – **AXE Colours**

4. **BARCELONA** Unknown location – **Unknown artist**

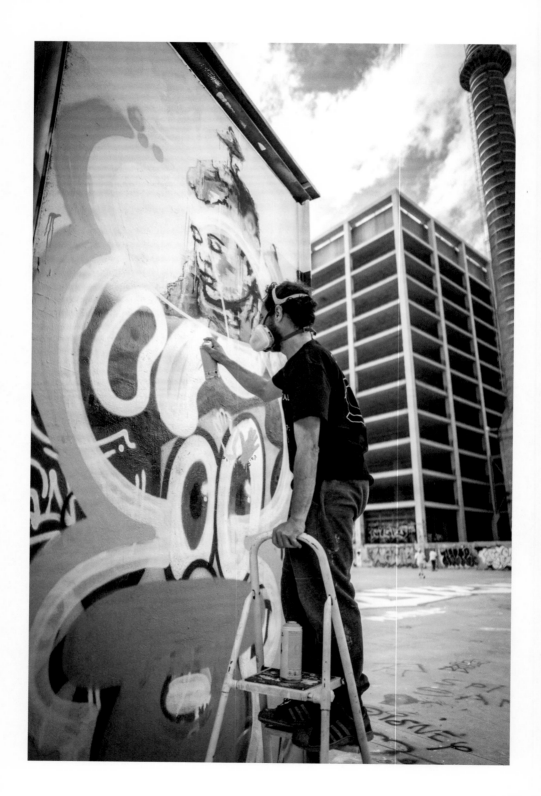

Drawings on the Wall

Spray cans, ghetto blasters, urban canyons. So begins the story of the modern graffiti movement. Initially closely associated with the rise of hip-hop culture, tags and pieces have for a long time led a wild, independent existence. They enhance architecture through autonomous interventions, use colours to provoke, and draw your gaze towards fractures in the urban landscape.

This is how the 1983 documentary Style Wars, which portrays the legendary pioneers from the five boroughs, begins. In the same year, producer Charlie Ahearn also released his NYC street culture film Wild Style, which also went on to become a source of inspiration for the young scene in Europe.

"Before 1984, I knew nothing about graffiti," says CMP One from Copenhagen, now in his early 50s, in an arte interview. Fellow graffiti artist SEK adds: "We watched Style Wars as young teenagers in the school holidays in Sweden. It was after that that it all started for us."
New York City is regarded as the birthplace of modern graffiti culture. This is where the scrawled "tags" were invented. The same goes for the large bubble writing that could already be seen on the painted trains of the Metropolitan Transportation Authority (MTA) in the 1970s. At the first block parties, graffiti was one of the four elements of hip-hop, along with rap, breakdance and DJing.

The corporate identity of the street.

The character of this Afro-American street culture was not initially commercial. Activists like DJ Afrika Bambaataa even managed to incorporate the New York gangs in peaceful, creative competition. The power for the stereo systems was drawn from streetlamps and the

colourful writing soon became a corporate identity for the movement from socially deprived areas. These images had a dynamic effect, electrifying teenagers and creative artists all over the western world.

Hip-hop served as a musical amplifier. However, before the graffiti style started to appear in European cityscapes, the stars of the streets took up residence in established institutes. As early as 1979, La Medusa gallery in Rome invited New York artists Lee Quinones and Fab 5 Freddy to preview their work in a vernissage.

High culture paid court to pioneering graffiti artists like Futura2000 and Rammellzee, who

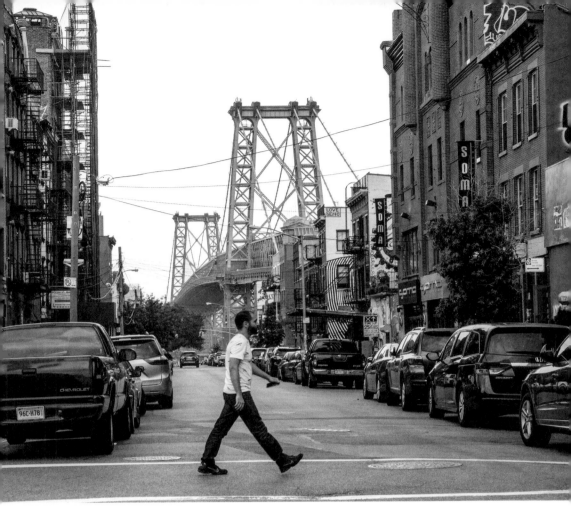

was both a rapper and producer. A crossover that also includes white pop music. New wave band *Blondie* enjoyed global chart success with the song *Rapture*. Among the lyrics: "Don't strain your brain, paint a train". The graffiti legend was growing.

Feeling and Hardness

Only a few artists in Europe mastered the artificial New York style, with its elaborate, colourful lettering and jagged typography. For example, in the 1980s the largest and longest graffiti area on the continent – the Berlin Wall – consisted of primitive slogans like *Gefühl und Härte* (Feeling and Hardness) or the rallying cries of squatters.

The kids from the European suburbs were still honing their skills. Talented individuals were shaping the scene. Here too, the preferred targets were traffic and transportation areas in major cities: concrete bridges, noise barriers, substations. Graffiti was seen as vandalism and criminal damage. The night-time spray tours through rail depots had a spirit of anarchy and adventure.

At the same time, regional scenes were developing differently. For example, a young French architecture student, alias *Blek le Rat*, lent the New York style a French touch. At the start of the 1980s, his hallmark, the rat, popped up as stencils on the walls of Parisian houses. "Paris

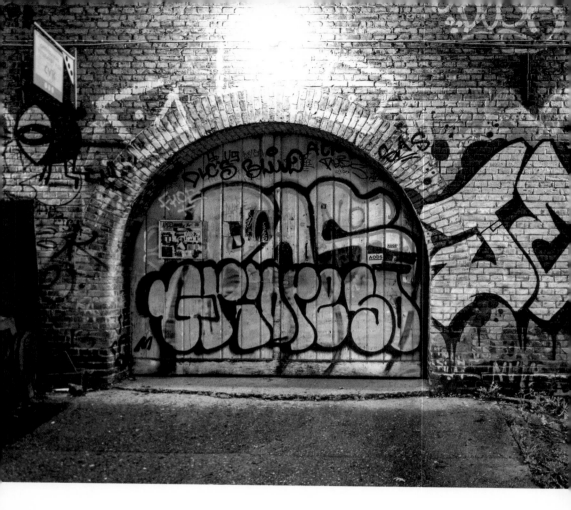

has a very different architecture to New York, so you have to react as a street artist," he said, describing his approach.

In Barcelona, it was El Xupet Negre whose trademark "black pacifier" appeared on house walls in Barcelona from 1987 (see also from page 62). Amsterdam favoured a hard style with angles and edges. Elsewhere, distorted comic figures were incorporated as stylistic elements.

From the mid-80s, this mix was also to be seen in the Federal Republic of Germany. As well as influential writers like Loomit, from Munich, rappers like the Stieber Twins and Torch from *Advanced Chemistry* were also out and about in the Heidelberg area. "The first thing we sprayed

was a motorway junction near here. That was in 1988," says Martin Stieber. Together with his twin brother, he has been active on the hip-hop scene from the middle of the 80s. Initially as breakdancers, then subsequently as graffiti artists and beatboxers.

Since 1992, the Stieber Twins have produced their own tracks. However, the era, in which music and graffiti go hand in hand, was drawing to a close at this point. Hip-Hop had long since grown too big. Rappers and producers no longer had time to head out on nocturnal graffiti sessions. While the artistic spectrum continued to grow, the spray pioneers handed over to a younger generation, who developed a new signature style in the 2000s.

Under the abbreviation *1UP*, Berlin group *One United Power Crew* used large rollers to paint grey building walls. Often below roof edges, widely visible. Specially-prepared fire extinguishers were used as spray canons. The result was huge tags that looked like frozen fountains. What was greeted with delight in some places was persecuted with special police commissions in others. It was a game of cat and mouse.

For the writers, it was all about making a mark. Without permission. After all, they wanted to conquer public space and emphasise fractures in the city design.
The European crews passed on their skills and built networks. Their names were to be known everywhere. Around the world, from Eastern Europe to Australia and South America, active communities of writers were established. The result was that the scene was developing constantly.

Street art complements the spray attacks and often works with pre-prepared materials like printed webs, which are stuck to walls like wallpaper. British artist Banksy, on the other hand, favours stencil graffiti and has developed iconic visual messages that have even been sold at Sotheby's fine art brokers.

Where inspiration once came from hip-hop tracks and sketchbooks, today's generation takes its inspiration from the Internet. Official graffiti areas, the "Walls of Fame", are a concept aimed at bringing the scene out of the dark. Graffiti has become part of the urban identity.

Making
a mark.

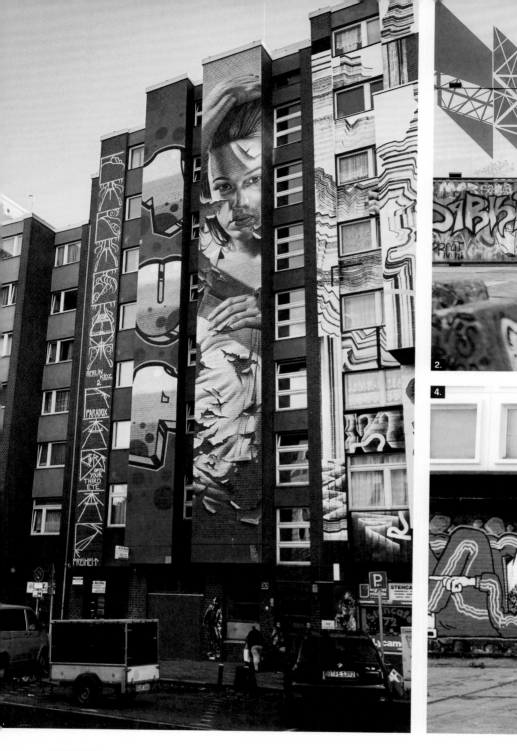

1. **BERLIN** Unknown location – **1UP Crew**
2. **AMSTERDAM** NDSM-Pier – **Unknown artist**

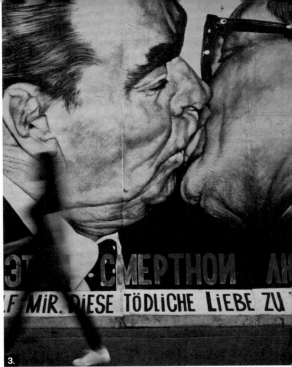

3. BERLIN East Side Gallery – **Dmitri Vrubel**
4. AMSTERDAM NDSM-Pier – **Unknown artist**

1. & 2. **LONDON** unknown location – **Unknown artist**
3. & 4. **COPENHAGEN** Christiania – **Unknown artist**

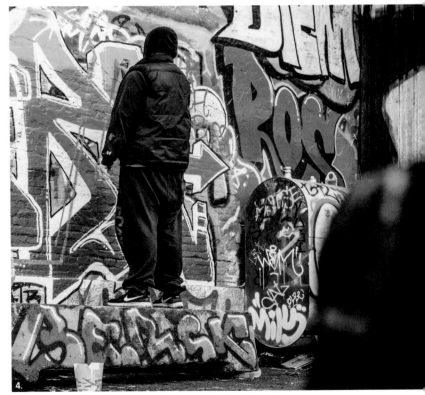

4.

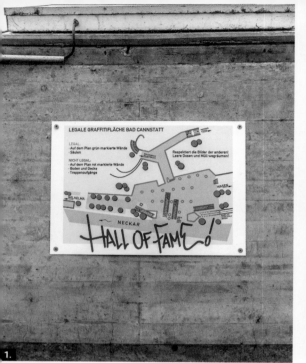

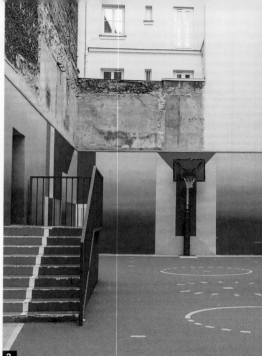

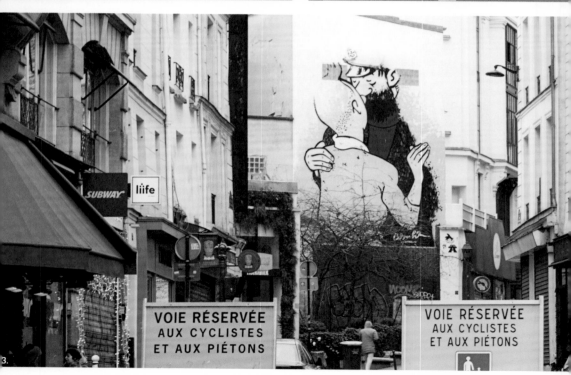

1. **STUTTGART** Hall of Fame Bad Cannstatt – **Unknown artist**
2. **PARIS** Duperré Basketball-Court – **Stéphane Ashpool**

4.

3. PARIS Tintin et le Capitaine Haddock – **Unknown artist**

4. LONDON Brick Lane – **Unknown artist**

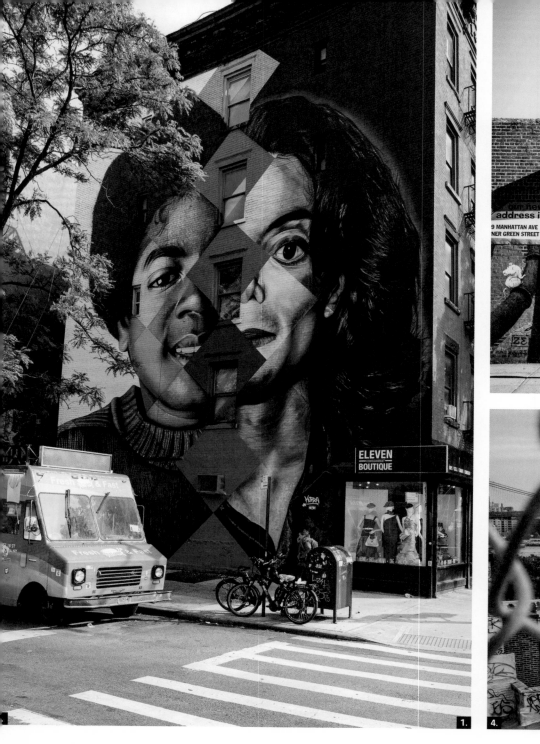

1. **NEW YORK CITY** Unknown location – **Eduardo Kobra**
2. **NEW YORK CITY** Unknown location – **El Xupet Negre**

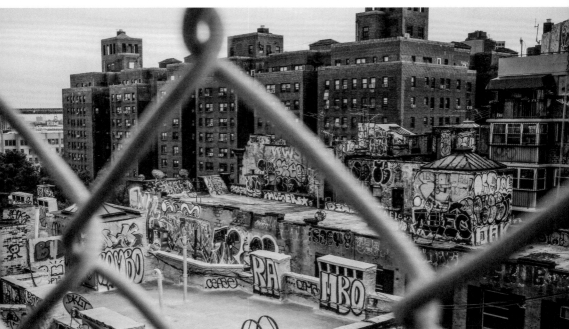

3. **NEW YORK CITY** New York Public Library – **Konstance Patton**
4. **NEW YORK CITY** Manhattan Bridge – **Unknown artist**

Pa
ris.

Paris 48° 51′ 24″ N 02° 21′ 08″ E

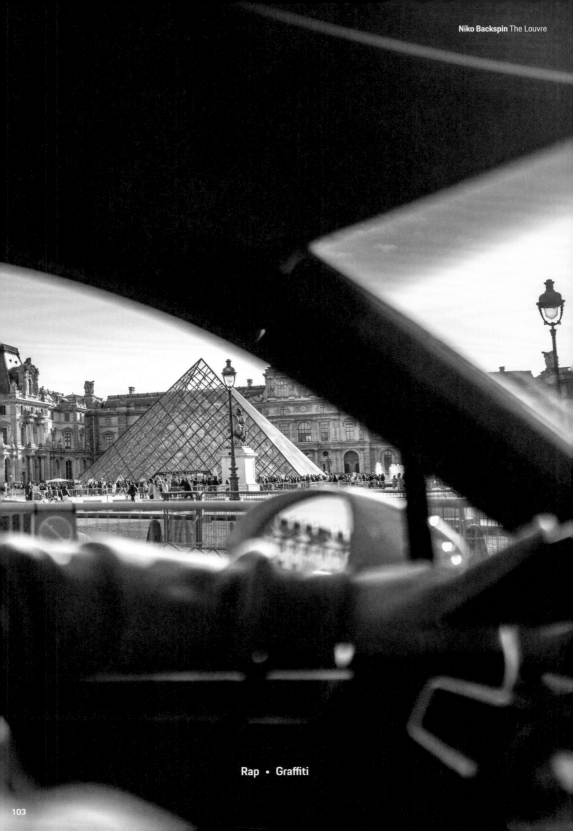

Rap • Graffiti

PARIS HAS
THE FLOW

LORD ESPERANZA

Théodore Despre aka Lord Esperanza is one of
France's up-and-coming rap talents. Widely read,
he is a shooting star of the Parisian hip-hop scene,
quoting literature in his texts and taking a critical
look at the political system. Although Despre is
only in his mid-20s himself, he nurtures the next
generation with his own label and signs French rap
talents in an effort to offer them perspective.

Paris 48° 51' 24" N 02° 21' 08" E

The river reveals the flow of the city. Paris owes its life to the
water. The city itself was born on one of its islands – Île de la
Cité. The Seine winds its way through the French capital for just
short of 13 kilometres – even its rocky banks are a UNESCO
World Heritage site. At least as important to the youth culture is
the city's hip-hop scene and its subculture.

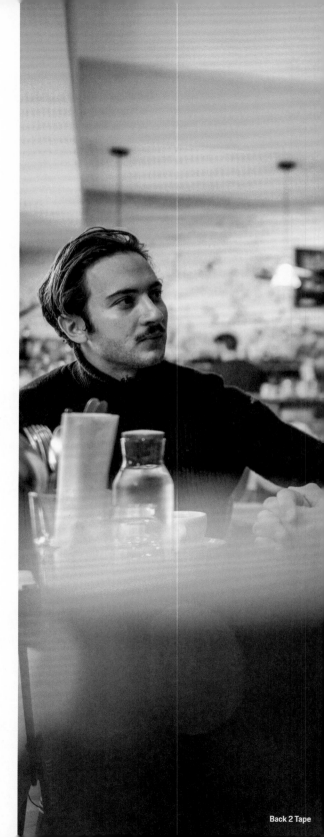

Paris is well-known as an epicentre for international art and fashion. However, even far away from the Louvre and haute couture, the city still has a lot to offer. Which brings us to the subject at hand: two people who are significantly shaping urban culture are Nicolas Couturieux and Théodore Despre. One is fighting for graffiti as an art form, the other for French rap. Importantly, however, both are fighting for their values and future generations.

Our first pit stop in Paris takes us to Théodore Despre, better known as Lord Esperanza. We meet him in a typical bistro in the heart of the city. Familiar sights like the Arc de Triomphe, Eiffel Tower, Louvre and Notre Dame are within walking distance.

Esperanza is sat with a glass of orange juice and a cup of coffee. Uncharacteristic of a rapper? Not necessarily. Perhaps more typical is the calm, melancholic aura surrounding him. The 24-year-old is a rising star of the French hip-hop scene and has been proving from a young age that rhymes need not necessarily come from the ghetto. As a child, Théodore Despre used to soak up classical literature, which would bring him closer to his parents. By the age of eleven he was writing poems, before moving on to his first novel.

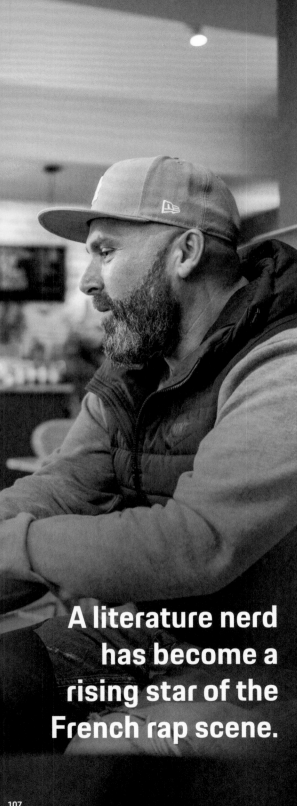

A literature nerd has become a rising star of the French rap scene.

Lord Esperanza still harbours that passion for literature to this day. In his texts, he frequently includes references to his favourite works. Even his stage name is inspired by a book: Esperanza originates from a new French version of *Robinson Crusoe*. However, he is far from as lonely and stranded as Crusoe.

Théodore Despre has been soaking up classical literature since his childhood days. At the age of just eleven, he was already writing poems.
Nowadays, the Lord appears at festivals and concerts around the world, has millions of clicks on YouTube and Spotify, and owns his own label, to which he has already signed up two newcomers. In his native France, his music is viewed as an alternative to seemingly stereotypical, violent rap lyrics.

He counters the current gangster monotony with profound and intellectual lyrics. And yet there is an inner conflict. This is what makes Lord Esperanza stand out. On the one hand, Esperanza quotes literature in his texts. On the other hand, the Lord takes the political system to task.

His few critics call him the "politically-correct, index-finger rapper". The French edition of *Rolling Stone Magazine*, on the other hand, uses the term "eco rapper".

Paris 48°51'24"N 02°21'08"E

From a purely musical perspective, the rising star and his companion Majeur Mineur fluctuates between melancholy, calm and reflection, as well as explosive, loud beats. And with great success: the album "Drapeau Blanc" and the single *Chateau de Sable*, which touches on a difficult relationship between father and son, gave the Lord his commercial breakthrough.

"I did not have an easy childhood. I grew up in two different words. My mother did not have a lot of money, but supported me in everything I did. My father, on the other hand, often took me

to classical concerts and readings, which still influence my music today," says Théodore. He has now been making music professionally for more than four years.

Lord Esperanza enriches hip-hop without excess. For example, he speaks out strongly against the use of drugs.

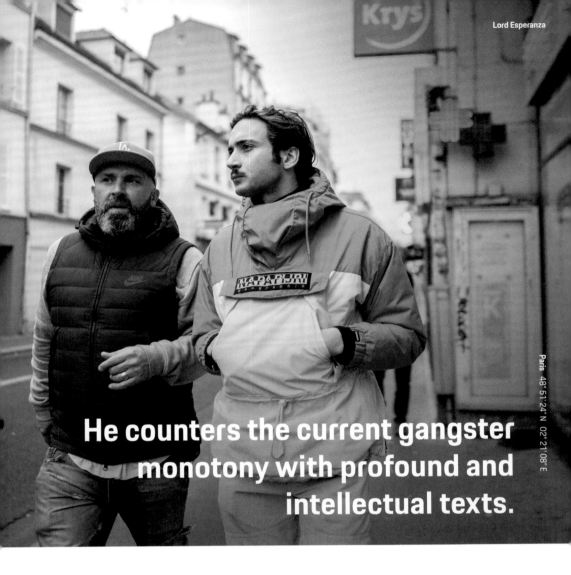

He counters the current gangster monotony with profound and intellectual texts.

Paris 48° 51' 24" N 02° 21' 08" E

— "Fortunately, there are still artists out there with a sense of responsibility. I am trying to be one of them. I want to give the next generation some hope. Times are crazy enough," —

says the musician. "Hip-hop started with a political opinion — today, it has increasingly become more about entertainment. I am trying to change that, along with many other great artists, here in Paris."

⚲ **PLACES TO GO & DRIVE**
Le Montfort Theater
Dance theatre with circus roots.
49 Rue du Montparnasse
75014 Paris

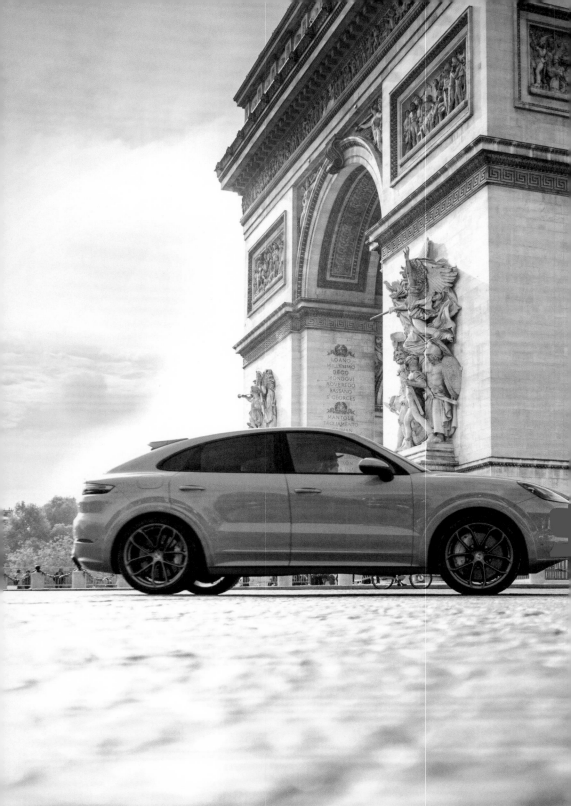

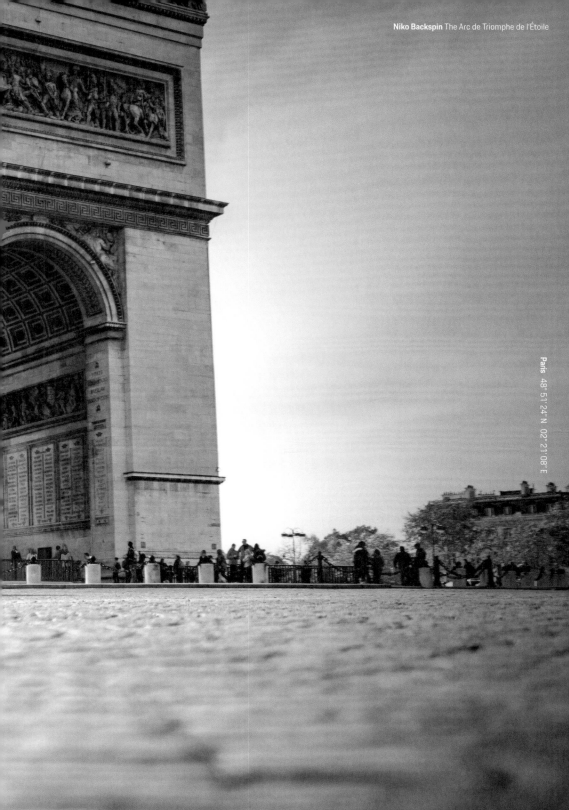

Paris 48° 51' 24" N 02° 21' 08" E

NICOLAS COUTURIEUX

Nicolas Couturieux is an art curator, hip-hop producer and editor. A veteran of the Parisian creative scene, he is firmly rooted in the hip-hop system. Couturieux, who regularly exhibits in Paris, Nancy and Toulouse, has set himself the ambitious goal of establishing graffiti as contemporary art and exhibiting it in France's major museums. Since the dramatic terrorist attack on the editors of the Parisian magazine *Charlie Hebdo*, the art curator has been actively campaigning for freedom of the press and regularly organizes exhibitions on behalf of the city of Paris to ensure the Holocaust is not forgotten.

Another of the city's heroes, who lives his life by precisely this maxim, is to be found in a small art print shop at 49 Rue de Montparnasse. The old print shop is located in the 15th district of Paris, in the neighbourhood between the old commune of Vaugirard and the historic part of Paris. Many streets have traffic calming measures in place. We reach Paris's city limits in the Porsche Cayenne.

The 210-metre *Tour Montparnasse skyscraper* is our lighthouse amid the confusion. We pass the Musée Bourdelle, the former studio of sculptor Antoine Bourdelle. Such great artists as Marc Chagall once used to ply their trade here. With its greenhouses and tethered balloon, offering expansive views of the city, the vast Parc André Citroën on the banks of the Seine is popular with tourists and families.

The art print shop, formerly known as "Mourtel Idem", is one of the oldest printing houses in the city. Even Matisse and Picasso were reproduced here – a historic place. In 2017, Nicolas Couturieux and a few like-minded people breathed new life into the old, heavy printing rollers.

The 38-year-old's life plan could hardly have been more colourful: art collector, curator, hip-hop producer and editor. Couturieux is a veteran of the Parisian creative scene. "I want to see graffiti established as an art form at some point, to be exhibited in museums," says Couturieux. "Because for many art lovers, graffiti is still an affront."

Paris 48° 51' 24" N 02° 21' 08" E

⚲ PLACES TO GO & DRIVE
Musée Bourdelle
Art museum in former studio of sculptor Antoine Bourdelle.
18 Rue Antoine Bourdelle
75015 Paris

Crocodisc 40
Music shop with focus on early hip-hop, soul and funk.
40 Rue des Écoles
75005 Paris

Monfort Théâtre
Dance theatre with circus roots.
106 Rue Brancion
75015 Paris

Couturieux is a veteran of the new Parisian creative scene. He wants to see graffiti in museums.

Paris 48° 51′ 24″ N 02° 21′ 08″ E

Couturieux's first attempt to pay homage to French and American graffiti artists has been going on since 2018 in Paris, Nancy and Toulouse, in cooperation with a collective for contemporary art: Le *Hangar107*.

– "Graffiti is my life. I travel the world a lot and check out special works. Returning to Paris is always like coming home. Our scene is really vibrant." –

The art lover engages at many levels to ensure this remains the case. "Whether sprayers, dancers or MCs, there are many good artists who do not have a decent label." With his national and international contacts, Couturieux tries to help, gets involved, and curates street art on behalf of the city. Always at the centre of what he does: the good of all.

In 2015, after the terror attack on the editorial office of Parisian magazine *Charlie Hebdo*, he worked with newspaper *Libération* and the Palais de Tokyo to raise thousands of euros to finance programmes promoting freedom of the press. Couturieux also regularly organises exhibitions to promote holocaust remembrance, skilfully linking the past, present and future with hip-hop culture.

Both artists, Nicolas Couturieux and Théodore Despre, reflect the soul of their home city: like Paris, they are very aware of their roots, and yet are still looking ahead. The city on the Seine, and its people, are giving European hip-hop culture the necessary depth and enriching it culturally in a way that no other metropolis could.

– "Rap is my job, which I hit
the sack with.
You have paintings, we have
whole cars in the studio" –

Harte Zeiten *La Familia*

— "Why go to Paris? Our art is free
of charge, outlines of Salvatore
Dalis on intercity trains." —

Schlangen sind giftig *Stieber Twins*

– "THE MUSIC BUSINESS IS A
COMBAT SPORT! CHANGE
YOUR LOCATION! YOU
WANT TO JOIN OUR CLUB,
BUT YOU DON'T KNOW THE
PASSWORD!!" –

Harte Zeiten *La Familia*

– "I said: Head up, son, grab a
handkerchief!
Life is full of ups and downs, like a pulley
Every man forges his own destiny
And hip-hop is like pizza: even when it's
bad, it's still really popular.." –

Ich so, er so *Eins Zwo*

— "You want a war, I'll
take your crew apart
like a mosaic." —

King of Rap *Kool Savas*

– "THERE ARE NO GUARANTEES,
HEADACHES ARE A SIDE–EFFECT
OF ASPIRIN." –

Vodka Apfel Z *Die Orsons*

– "If work here is
not force times distance,
then prove me wrong.
Because next I'm going
to move an inert gas as easy
as though it were Tetris." –

Kopf, Stein, Pflaster *RAG*

Punchlines

On his album *Feuerwasser 15*, Curse released his much-quoted "10 Rap Gesetze" (10 Laws of Rap) in 2000. A mantra for the hip-hop community. A self-reflection of the culture. However, how have these lyrics influenced the European rap movement? And how exactly are these lines to be construed? An interpretation of what just might be the most important rap lines in Germany.

If you want to talk about hip-hop, you need to talk to Michael Kurth. Born in Westphalia, Curse has played a major role in German hip-hop history. He has released eight studio albums and collaborated nationally with major artists such as Kool Savas, *Silbermond*, Dendemann, Max Herre, and Marius Müller-Westernhagen. He has also been involved in international projects with *The Roots* and Promoe, playing electronic beats, piano ballads, banging hooks, all with a voice that the ear is drawn to. The Berlin resident's career has always been shaped by his faith in Buddhism, his work as a yoga instructor, meditation expert, podcaster, and his self-reflecting, intelligent and always experimental nature. For many, Michael Kurth is the hip-hop fan he sings of in his texts.

— "Yo, relax
This sound is going to knock
you off your chair
You've never seen anything
like it, this is what
hip-hoppers do." —

Reimemonster Afrob & Ferris MC

1

Firstly: Ask yourself whether it is really worth it / Are you rapping because it comes from the heart, or because the shit is commercial at the time?
Hip-Hop is complex. Curse uses the art of creating rap as a form of self-reflection to determine whether rap really means so much to him that he is willing to make major sacrifices and devote himself to this art form. It is the fundamental question of what the motivation is behind rapping – real or fake, culture or commerce.

Today, this principle is more topical than ever. As it was when "10 Rap-Gesetze" appeared on the scene, the German hip-hop landscape is a financially lucrative market, which has enticed some protagonists who do not necessarily value hip-hop as a form of art and culture, but simply as a tool, with which to generate profit. How authentic is rap?

2

Secondly: Please don't embarrass yourself by copying / Of all those who write, only a handful are really unique and true to themselves.
Copying is, and has always been, frowned upon in hip-hop. This principle remains valid to this day. However, Curse's rap law is also targeted at another level, as plagiarism always exposes the copycat as being devoid of ideas and uncreative. Here, hip-hop's culturally-intrinsic do-it-yourself philosophy demands that the protagonists should take the circumstances of their personal environment and use them to create something new and, above all, something individual. It is not lacking a degree of irony: with its cultural technique of sampling, quoting and remixing, hip-hop sometimes behaves like a kid in a sweet shop when it comes to ideas outside its community. Within its own circles, however, it is very careful to weed out any copies.

– "Freedom means making decisions. Freedom means feeling free to change your mind now and again." –

Freiheit Curse

3

Number three: When freestyling, you have to separate practice from performing / Better ten hot lines than to waste ten minutes / The crowd can turn really cold if you're not on fire / Put down the mic, say "Peace", and crush it when you return.
Freestyle – the freely-improvised spontaneous creation of rhymes in a flowing context – has decreased in popularity. The ability to improvise is still valued and admired among rappers. As a skill, however, it is no longer seen as one of the basic expectations, as was the case in the 1990s. However, freestyle, just like rap is in most cases, is first and foremost a matter of practice. Rigorous training. Here, Curse again urges those performing rap to take a good look at themselves, and to own up to their own failures in good time.

4

Number four: Sit yourself down, sharpen your pencil, grab yourself some paper / Learn to respect MCs and study their strengths.
Curse's fourth law of rap focusses on the pursuit of perfection – the perfection of one's own skills and talents. On the other hand, it makes it absolutely plain that one should not underestimate one's counterpart or a respective task. The constant search for constructive improvement. And the will for healthy respect in all situations.

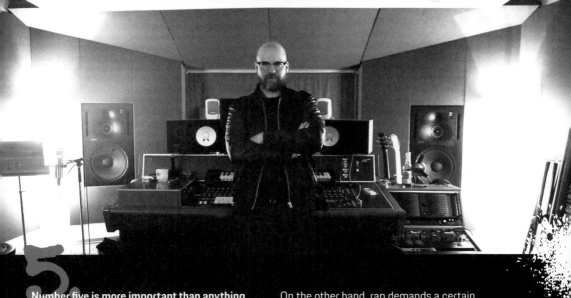

Number five is more important than anything else in this business: / You have to understand that the competitive nature means you will be dissed.

Rap is competitive. The competitive aspect, the battle, is probably the original principle of hip-hop. It is in the DNA of this culture to be better and stronger than the rest, and to use outstanding talent to stand out from the crowd.

True to the adage "the competition never sleeps", the fifth law encourages rappers to remain vigilant in this antagonistic environment. The constant threat of a possible challenge to a showdown means you should always be prepared and cautious. In the era of social media and video statements, this has become even more important away from the expected fields, such as battles and diss tracks.

Six: Find your own repertoire when you're rapping / Where you put the words is the formula for your context and master plan

Curse has incorporated two premises in this statement. On the one hand, the imperative need for authenticity in rap is once again emphasised. Finding your own language is absolutely essential in rap. Examples of this are Kollegah's "Kid", or "Mois" (friend), and other words like "derbe" (foul)

On the other hand, rap demands a certain feeling for language, in order to express oneself. Otherwise, not only could it lead to misunderstandings, but even to destructive situations. If RIN describes your friends as "Fische" (fish), this is a very malicious insult, which has been established as slang in Baden-Württemberg for a long time. However, he would get little response from a rapper from Schleswig-Holstein, for whom the word "Fisch" means something different. In other words: be careful what you say and where you say it.

And that leads us straight to number seven: You have to love hip-hop as though you have always stayed nothing more than a fan / The fame and all that shit is cool, and you should enjoy it / But none of us would be what we are today without guys who remain down-to-earth

Maybe the most important quote – and a constant mantra of the whole Back 2 Tape crew, led by Niko Backspin. Humility and a down-to-earth attitude. Curse believes that it is appropriate to appreciate what you have achieved to a certain extent. However, success should never lead to delusions of grandeur. A kind of confident, but critical humility. Always coupled with respect for one's competition and pioneers. In brief: an appreciation of hip-hop culture as a

8

Number eight is similar to number seven, so it is easy: Respect the breakers, DJs and graffiti

Rap law number eight reveals Curse as clearly a child of the nineties, when the German hip-hop scene still clearly saw and referred to hip-hop as a cultural package of breakdance, rap, DJing and graffiti. On the one hand, it is about respecting and appreciating other disciplines, which receive less attention than the largest segment in the media — rap music. On the other hand, it is about bowing down to the pioneers of this culture, who had to fight certain battles before present-day rappers received the media opportunities they have today.

However, the pillars of hip-hop culture in Europe have dispersed to such a great degree since the eighties that this law is no longer really applicable. Anyone who wanted to spray graffiti in 1983 could, and often had to, seek contact via breakdancers or hip-hop DJs. Today, the fields are no longer so closely linked. This is why there are rappers who have never come into contact with graffiti or breakdance, and vice versa.

9.

Number nine: Don't sleep under any circumstances, but do dare to dream / Focus on your goal, to overcome hurdles

Essentially a really mundane line from an autograph book, defining idealism and the pursuit of perfection as a motivational basis. What Curse is basically doing here is expanding on the famous Nas quote I never sleep, 'cause sleep is the cousin of death. However, Curse takes the advice regarding productivity and self-optimization and adds the dream as an idealistic target. Furthermore, the state of a focussed perseverance is also proposed as possible guidance. Nowadays, you would speak of attentiveness. When success is strived for (however it is defined), the idea behind the ninth law is a very reasonable guide, which will never age.

10.

Number ten is actually the first rule of all: Don't ever take on Curse! That's all from me, now the others can do their talking

The bottom line is a question that everyone must answer for themselves: does this statement still apply?

– *"You can achieve anything, if you want it But wanting something does not mean chilling out all day."* –

Flouz kommt Flouz geht *Nimo*

– *"THERE IS THE DIFFERENCE YOU SEEM SURPRISED, BUT THAT IS OUR SHIT AND IT'S HAPPENING STATE-WIDE AND WHEN WE'RE ON TOP, NOBODY'S GONNA BRING US BACK DOWN LOOK WHO'S NODDING THERE, EY LOOK WHO'S NODDING THERE."* –

Unterschied *Massive Töne*

– "IT WOULDN'T BE THIS WAY, IF IT
HAD NEVER BEEN HOW IT WAS." –

Schlüsselkind Cora E.

— "The circle stays small,
as only God knows
Bro, who is your friend,
who is your foe?" —

Matrix Apache207

— "Nobody helps you when you
hit rock bottom
But everyone wants to be your
friend when you're on the up." —

So Gott will Fard

– "It may be that you
meet twice in a lifetime.
But the second time
could be too late." –

Bye Bye Cro

– "Time to demand styles,
Do you want cyphers of soap operas?" –

Malaria Stieber Twins feat. Max Herre & Samy Deluxe

– "WHEN YOU HAVE FAME, PEOPLE
ARE FRIENDLY
AND WHEN YOU HAVE MONEY,
EVERYONE CAN BE BOUGHT." –

Bling Bling Juju

— "Hip-hop needs people
But people need hip-hop." —

Dein Herz schlägt schneller Fünf Sterne Deluxe

– "DO YOU STILL
RECOGNISE THIS? REAL
HIP-HOP
IN A COUNTRY, WHERE
YOU CAN EVEN FLOP WITH
A HIT." –

Poesiealbum Samy Deluxe

– "Good things need time
Bad things need hype." –

Fhug Life 3Plusss

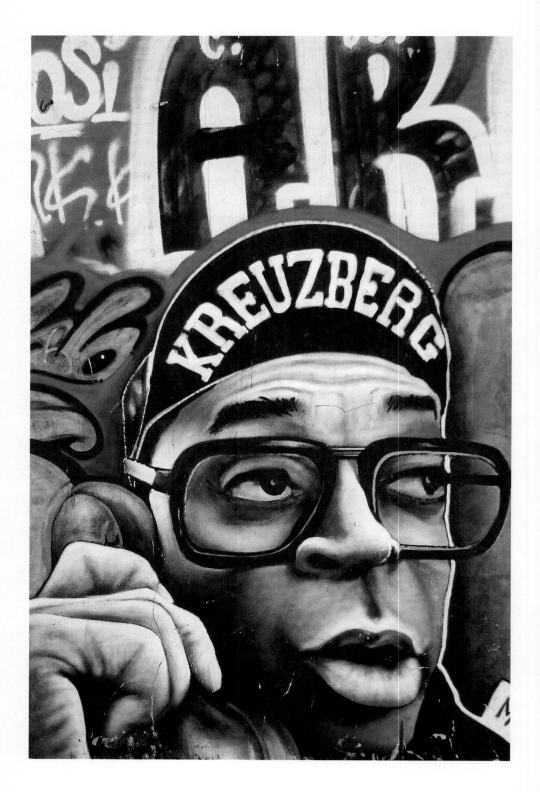

Homies, Bosses and Lamb kebabs

As the most important phenomena in youth culture for years, hip-hop has had a major impact on the languages of Europe. In Germany, Xatar, Haftbefehl & Co. are helping to shape the language, and there are also interesting interactions between street and hip-hop language in France and Spain, Denmark and the Netherlands. This shows that there are no rules and remix is part of the deal.

The lexicographers from German dictionary giant Langenscheidt-Verlag have been naming the "Youth Word of the Year" since 2008. In 2020, the various youth scenes themselves were finally allowed to submit their own suggestions for the first time. The choices made are already a "testimony to how hip-hop and its exponents shape the language", according to Swiss hip-hop magazine *Lyrics*.

What is noticeable when you consider the current "youth words of the year", which are strongly influenced by hip-hop, is that many of the terms are not made-up words or Anglicisms, but existing words that have been hijacked and reinterpreted by rappers. One example is the adjective "wild", which takes third place in the ranking. *Born To Be Wild* was a contemporary anthem of 1968 hippie culture. The fact that "wild" is still widely used by young people 52 years later has a lot to do with rapper Xatar. He first used the word in an Instagram story in 2019: at one point he says: "It's too wild", then adding a rattling "chhhrrrrr" that is reminiscent of the laugh of Sesame Street's Ernie. What Xatar is trying to say is "take it down a gear, people".

Xatar now has more than a million followers on Instagram. As a result, his video stories spread online in a matter of seconds, often in the form of memes, small snippets that can function like mini jokes, consisting of only the punchline. The "wild" meme lasts less than three seconds. It is circulating on the net in its original form as well as in countless variants. YouTubers have incorporated it into their videos, Xatar's hip-hop comrades Azad and Farid Bang published the piece "Too wild" and gave Xatar the props as its inventor. Influencer Inscope21, whose YouTube channel has more than 2.6 million subscribers (for comparison, Bild newspaper does not even sell half as many copies per day), turned "wild" into "wyld" in one

of its clips to make it look fresher. From there it continued to circulate: "Another server crash while home schooling? Too wyld, chhhrrrrr. "

"Köftespieß" as an expression of longing.

Let's stick with Xatar for a moment: As one of the greats of the hip-hop scene, he represents a dazzling value chain: rapper and label boss, restaurateur and entrepreneur, writer and fashion designer. Part of his story is also that he went to jail in 2009 for a robbery on a gold bullion truck. Legend has it that it was during his time in prison that he found the inner strength to rise to become a mogul of the German rap scene. When a television team visited him behind bars and asked what he was looking forward to most when he was back on the outside, Xatar answered: "I want a nice lamb kofta kebab (Köftespieß)!" More than ten years later, the term "Köftespieß" also appeared on the longlist for the youth word of the year as an ironic term for longing for freedom. Xatar's language can be found in many forms, in his lyrics, interviews, Instagram stories, in the texts of other rappers. His words are quoted, often in isolation – resulting in a kind of remix.

This free use of language reflects what it is that characterises the youth culture of hip-hop in its entirety: the scene celebrates itself and builds a densely interwoven frame of reference. Hip-hop blurs the lines between authenticity and pose, honesty and irony. Everything is exactly the same, but the meaning can be quite different. Consequently, the language is not tangible

either. It flows, so it has a flow, very similar to the rhymes of the MCs.

At the same time it is quick-witted and has a pulsating inner rhythm. The creative and idiosyncratic nature of the hip-hop language is very attractive to young people. It differs from the formal language of everyday life that young people experience at school, in training or at home. It is exactly this difference that youth culture targets: it is all about setting yourself apart and finding your own identity. This also works well when the second or third generation of families from an integrationist background develops its own version of German with the help of hip-hop, combining their lived experience with their parents' cultural roots.

Poetry, politics and a separate language culture
In his research, Hamburg-based linguist Jannis Androutsopoulos deals with the influence of hip-hop on linguistics. He affirms that there is no other subculture that has taken such firm roots in youth culture. One reason for this lies in the educational and creative freedom that hip-hop offers: music is just one mainstay of the scene, plus elements such as DJing, breakdancing or graffiti, which together result in a cosmos that is very popular among youth workers: no open door without a rap battle, breakdance training or graffiti workshop

That's why the "art of collage", that is, the bringing together of different elements, is also a central element in hip-hop language, as Androutsopoulos claims. He includes personal word creations and language crossovers in this: "You can find archaic language usages, neologisms and idiosyncratic abbreviations in a lot of different rappers, all of which are thrown into the mix as poetic and artistic compositions," the linguist stated in an interview

for Deutschlandfunk. This form of attention to the formal details of language is quite unique and cannot be found anywhere else in contemporary pop music:

– **"You have to look at the texts in their entirety, as a poetic language that also conveys political and cultural messages."** –

homophobia in hip-hop, as well as too much anti-Semitism. To refer to the battle-based nature of hip-hop, i.e. a playful face-off in which points are scored by provocation, is no longer a sufficient excuse. Some exponents have recognised this and now distance themselves from their earlier work. Is this change sustainable? The tracks of the future will tell.

Stress in Spain, regionalism in Denmark
The influence of the hip-hop scene on language is a worldwide phenomenon. The Californian anthropologist Prof. H. Samy Alim formulates the idea of a global "hip-hop nation" in his books: no matter what regional rap culture you look at, there are similar linguistic mechanisms to be found everywhere.

– "These include the original roots in Afro-American language and discursive practices, regional variability and a synergy of speech, music and literature – and last but not least a link to socio-political injustices such as police brutality or the disproportionate imprisonment of ethnic minorities." –

The power that can arise from this political dimension was demonstrated in Spain in spring 2020: a court sentenced Catalan rapper Pablo Hasél to jail for insulting the monarchy, glorifying violence and threatening witnesses. As a result, protests and violent riots broke out in Spain for days. A peculiarity of the Spanish scene is that rappers like Hasél or Valtònyc, who was convicted in 2018 and went underground in Belgium, are part of the autonomous Antifa scene. There are also decidedly left-wing hip-hop acts in Germany, for example the Antilopen Gang or Sookee, however these are (still) in the minority.
It is interesting that the assimilated Anglo-American dominance in hip-hop is gradually diminishing. The USA is the country where it all began, and there is also an innovative rap scene in the UK. However a kind of rap Brexit took place here a few years ago: Acts that are giant in the

UK are less well known on the European mainland. Acts like Slowthai or Stormzy appear less in the rap scene in Germany than in music magazines; sub-genres like UK Drill are idiosyncratic phenomena in London, but don't always make their way to Europe.

With the exception of the Vatican, there is probably no country that does not have a hip-hop scene in its own language. This also applies to Malta, where Johnston Farrugia, a.k.a. Hooligan, raps in Maltese. In the Netherlands, the texts of acts like Boef from Alkmaar, Kempi from Eindhoven or Sevn Alias from Amsterdam seem like their own artificial language made up of Dutch, English and a barely identifiable slang derived from ancestral countries of origin. The Danske Rap scene is astonishingly diverse, with Danish offering the acts the advantage of being very regionally influenced anyway: this provides a starting point for rappers like Sivas to further distort the language, in his case with influences from Iran, the country of his parents.

Rap as a platform for the banlieues.

The world's second largest market for hip-hop acts is in a country not directly associated with rap: France. In an interview with Bayerischer Rundfunk, the German rapper RAF Camora explained the typical course of trends as follows: "It's always the same: First something happens in America, then it comes to France and as soon as it is in France, the thing will be Europeanised – and three to four years later it ends up in Germany."

The driving force behind French hip-hop is found in the banlieues, the suburbs considered political problem areas, which also form the nucleus of a creative youth culture. While the language from the banlieues played hardly a role in French literature and film for years, suburban youth has made itself heard through their rap tracks. Acts like Suprême NTM or IAM did this in the 1990s with lyrical texts that were almost like social reports. Later, Booba, one of the stars of the scene, introduced the harsh language of the streets into his lyrics, after which this was reflected back on the street. Today rap shooting star Lord Esperanza in Paris takes things to the next level with almost literary rap texts.

"I remember when Booba was the first to rap in street slang in the early 2000s," recalls RAF Camora. "As a French native speaker, I noticed back then that everyone thought it was funny that someone could rap the way you speak. And I thought to myself: When will people from a migration background start to rap the way they speak in Germany? That's when Bushido came along."

When violent unrest broke out in the poorer French suburbs in mid-2005, the tone changed again. Kaaris represents the new generation with his hardcore rap tracks, one of his early hits, "Zoo", includes the line "les singes viennent sortir du zoo". The German rapper Haftbefehl named one of his tracks afterwards: *Let the monkeys out of the zoo.* You actually have to read the text by Haftbefehl several times in order not to miss any of the numerous references.

The Offenbach-based artist dissects the myth of America, countering it with the "realness" of his homeland. There's sex and violence, a name drop for Frank Sinatra and Mafia boss John Gotti, plus references to Haftbefehl's own work, as a sign that it's all just a game. It is small wonder that Haftbefehl, whose language is a synthesis of "on-the-nose" rebellion and critical complexity has proven a hit not only on the streets, but also in the culture pages of the newspapers: not even the greatest German poets are subject to as many levels of interpretation as Haftbefehl from Offenbach. It is therefore almost certainly more than just a rumour that a song by Haftbefehl has become a familiar refrain in the still strictly hierarchical editorial conferences of the German broadsheets: "Chabos wissen, wer der Babo ist" (Homies know who's boss).

Stutt
gart.

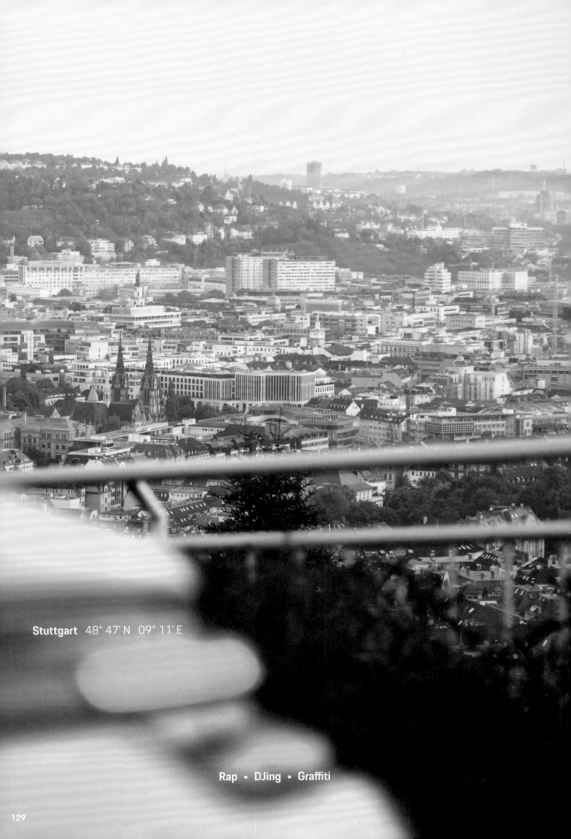

Stuttgart 48° 47' N 09° 11' E

Rap • DJing • Graffiti

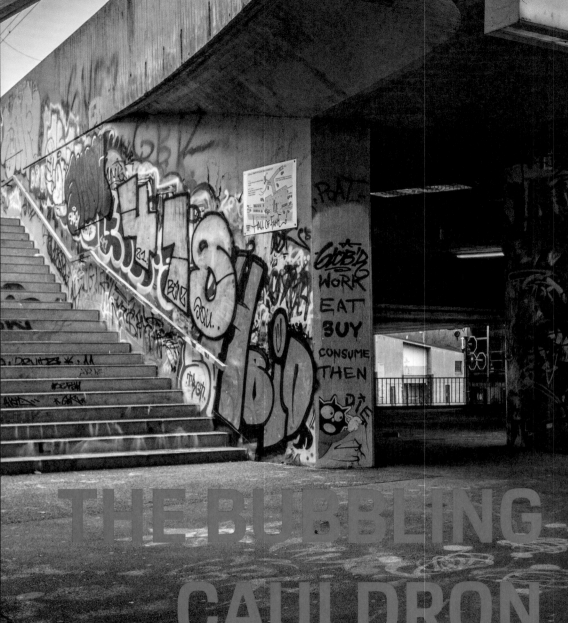

THE BUBBLING
CAULDRON

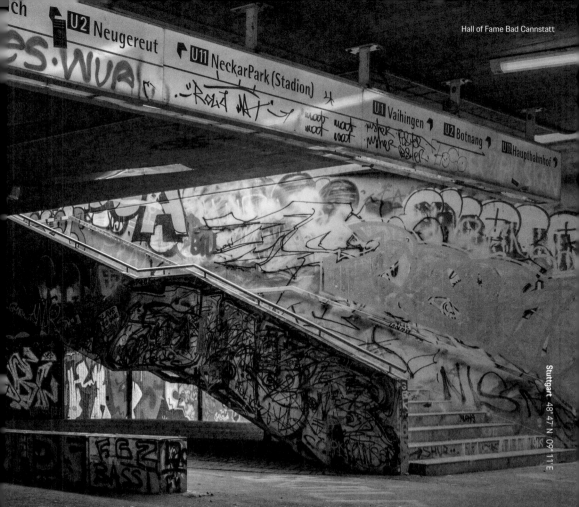

Stuttgart 48°47′N 09°11′E

The history of German hip-hop is inextricably linked with Stuttgart: American hip-hop culture fell on fertile soil in the cauldron, as the city is affectionately dubbed owing to its valley location. And from there it affected the musical and cultural landscape of an entire country: a cradle of German hip-hop with bands and artists such as Die *Fantastischen Vier*, *Massive Töne*, *Freundeskreis*, Cro, Bausa, Die Orsons and the hip-hop collective *Kolchose*. Hip-hop culture is ubiquitous in Stuttgart to this day — and it is impossible to imagine the city and region without it.

Stuttgart is not only the home of Porsche; it has been a focal point of the German hip-hop scene for many years now. At the end of the 80s, Die *Fantastischen Vier*, consisting of Smudo, Michi Beck, Thomas D. and And.Ypsilon, became pioneers of a new German rhyming culture, which saw hip-hop rise from the underground and break into the charts. Fanta 4 have been on the stage for around 30 years now, make regular TV appearances, are voice actors for movies, and have added countless music awards and gold records to their personal collection.

During the coronavirus pandemic, it was lead singer Smudo who really made a name for himself and, through his involvement with the development of the luca app, a data-protection-compliant contact data management and contact tracing app, expanded beyond the traditional rap business. The four Stuttgart residents are undoubtedly legends and pioneers of rap. And yet Thomas D., Michi Beck & Co. have regularly been subject to criticism during the development of German hip-hop culture.

The often quoted "fun rap", which attained its first commercial and media peak in 1992 with the single *Die Da!?!* from Stuttgart, was viewed with misgiving by the hip-hop community. The first domestic rap stars were born, but not respected. Too nice, too poppy, too self-deprecating, texts that were too simple, not political enough. To sum it up: too far removed from the fundamental ideas of the movement that emerged in the USA by uniting DJing, rap, breakdance and graffiti. So the heart of the metropolis focussed on the crucial question: what is hip-hop?

Welcome to the metropolis.

As we meandered from Zuffenhausen towards Stuttgart city centre with the Porsche for *Back to Tape* in 2018, we were headed in the direction of Wilhelmspalais. Back then, the Stadtmuseum Stuttgart was planning an exhibition called *Kolchose Palace* – covering the history of a hip-hop collective famous across borders. 25 years of history of beats and movement. In the passenger seat of our Panamera was Wasilios Ntuanoglu,

better known as Duan Wasi, founding member of Massive Töne.

In 1991, Wasi, along with Schowi, Ju, and DJ 5ter Ton, launched a golden age of German rap, in which young musicians from Stuttgart used expressive texts and confident flows to describe a previously neglected reality – and, along the way, saw the cauldron go through the roof musically and become a role model for other German cities.

Willkommen in der Mutterstadt, der Motorstadt am Neckar, Mekka für Rapper (Welcome to the metropolis, the engine city on the Neckar, Mecca for rappers) was a line from *Massive Töne* on their debut album *Kopfnicker* in 1996, which saw Stuttgart crowned a stronghold of hip-hop for the first time. A milestone for German rap. Incidentally, the LP was a real hit back then, with top-class features from *Freundeskreis* lead singer

Max Herre and the "rhyming monster" Afrob, both of whom have been long-time protagonists on the Stuttgart rap scene. Still characteristic of the local hip-hop culture: a collaboration of artists who represent the city's diversity.

– "There is a certain culture of working together that we have cultivated in and from Stuttgart. Here, there is a pluralism of different styles, and styles with many different creative cells." –

📍 **PLACES TO GO & DRIVE**
Porsche Museum
Automobile museum.
Porscheplatz 1
70435 Stuttgart

One for the rap ...

"That's why our focus was always on the four traditional basic elements of hip-hop and we tried to keep Stuttgart at the heart of the process," said Wasi as we pulled up at Wilhelmspalais. This is where creativity meets history – and hip-hop meets Stuttgart. Kolchose, a free artist collective, is a loose union of rappers, DJs, breakdancers, sprayers and other artists, who had a major influence on the German hip-hop movement both musically and culturally right from the very beginning, and who represent and unite the heart of the Stuttgart street culture scene to this day. 0711 Club, characterised by Stuttgart greats such as Emilio and DJ friction on the decks at *Schräglage* or Prag, became the city's most legendary club night. What sounds totally normal today was pretty daring for Germany back in 1996: a pure hip-hop party. "Without it, Stuttgart would only be half as cool," claimed the local *Stuttgart* paper.

And this was confirmed by Duan Wasi: "The whole hip-hop thing started through dancing back then. In the beginning it was only really breakdancers there. My brother got caught up in the breakdance wave in the eighties and then I was one of the kids who just danced because I thought it was cool," explained the creative head as we ambled around the museum. "One reason why hip-hop really took off here in particular was the US military bases in and around Stuttgart. Like in Heidelberg and Frankfurt, they were a key factor in the development of hip-hop culture." Hip-hop reached its preliminary culmination in Stuttgart at the end of the 1990s: 4:99 (Die *Fantastischen Vier*), *Esperanto (Freundeskreis)*, *Überfall (Massive Töne)* and *Rolle mit Hip-Hop*

(Afrob) topped the charts for weeks in 1999. The path had been laid out for many more artists in the city. Specialist agencies and labels made Stuttgart a centre for hip-hop culture. Artists such as panda-masked rapper Cro went on to become mass phenomena – they filled concert halls, stadia and captivated both young and old fans alike. In 2014, "Spiegel" wrote that hip-hop was the new people's music.

... two for the movement ...

Before we visited the *Kolchose Palace* exhibition, we toured the Porsche Museum in Stuttgart-Zuffenhausen with Wasi, looked around the sports car manufacturer's world-famous archive and tested the interactive sound installation *Porsche in the Mix*. For Duan Wasi, the trip was also a change of perspective as he described himself as not being a fan of cars.

— **"I focus more on the essence of the technical object, the history and the iconic design, which speaks to me,"** —

explained the artist. And he even went a step further: Every sports car has a melody – but what does a Porsche sound like, when its sound is actually converted into music?

The Stuttgart hip-hop producer created an auditory new design at the end of 2018. He transposed the form and structure of the design typical of Porsche and its related associations to several scenarios: urban, historical, technical are just some of the adjectives he used to open up the scope of interpretation for the listener. "First, I looked for auditory equivalents of terms such as pressure, form, dynamics, speed and spin," said Duan Wasi. Using various design methods from signal processing, such as multiband filter and granular synthesis, the sounds were formatted and added to the sample collages. In summary: the man from Stuttgart mixed real Porsche sound with beats and expressed this feeling on his record *Loop Routines*. The musical experiment was released as an exclusive vinyl record with a limited edition of 500 records.

Stuttgart 48° 47' N 09° 11' E

DUAN WASI

Wasilios Ntuanoglu, also known as Wasi alias Duan Wasi, is a founding member of the Stuttgart rap crew *Massive Töne* and an integral part of Kolkhoz, hip-hop artists' collective from Stuttgart founded in 1992. His work has been discussed in a cultural and literary context in Germany ever since his texts were included in the cultural history collection of the city of Stuttgart, . In 2018 he tried a musical experiment and produced a completely new sound from the sound elements produced by the Porsche 911 GT3 RSR (type 996) Le Mans vehicle.

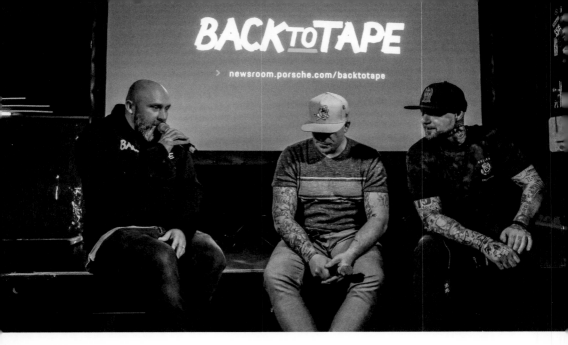

BEAT BOY DELLES

Samy Deluxe has been accompanied by
Christian Delles, aka Beat Boy Delles, since
they opened the Esche youth culture center
in Hamburg in February 2016. Now the
center's artistic director, Beat Boy Delles
has been breakdancing and painting graffiti
since 1990. Since then he has worked as
a professional dancer and choreographer,
passing on values and hip-hop culture
to future generations in workshops and
campaigning for social initiatives in his home
town of Hamburg.

The musical fly line created by the former
member of Massive Töne is a textbook example
of the metropolis on the Neckar. "The whole
Kolchose construct has always been a huge
network of people contributing their inspiration.
Openness and freedom have always been key:
we are by no means exclusively hip-hop people;
anyone who is creative and wants to contribute
has always been welcome," said Duan Wasi. "And
Kolchose means something different to everyone.
Just like the hip-hop movement represents
something different to everyone."

... shaped by the area from a young age

Scotty76 is a real institution of the whole
movement with all four basic elements of hip-
hop. And his body bears the proof: *Hip-Hop is
my Life*. We picked up the tattoo artist from his
Stuttgart studio. Originating from the Heidelberg
district of Emmertsgrund, Steve Patzschke, as he
was originally known, couldn't be parted from a
paintbrush even in Kindergarten. He is fascinated
by colours. And by music. He raps, sprays and
dances. He came into contact with the pioneers
of hip-hop culture in Germany at an early age
in Heidelberg: he was a breakdancer in videos
for Torch, Toni-L and Advanced Chemistry, and

← **SCOTTY76**

Around the world with hip-hop: Stuttgart tattoo artist Scotty76 is the embodiment of 25 years of hip-hop culture. He has danced in videos by Torch, Toni-L and *Advanced Chemistry*, toured China and the USA with hip-hop, was a member of the *Southside Rockers* and witnessed the birth of the *Stieber Twins* in Heidelberg and their legendary album "Fenster zum Hof". Scotty76 first started working on graffiti and the design of artworks, record covers, sculptures and canvases at the age of 12. He now runs a successful tattoo studio in Stuttgart and works for brands such as Adidas and Converse.

was there when the Stieber twins recorded their legendary album *Fenster zum Hof.*

He went on to become part of the Southside Rockers, toured China and the USA with hip-hop, released his own DVD *Scotty's World* on the Deluxe Records label. He owes a lot to hip-hop – but despite, or perhaps thanks to, his diverse talents in all disciplines, he doesn't think much of separate elements. "For me it is one thing. When I came into contact with all the movements, all of it – from tags, through scratches, to the hot bars and the backspin – captured my head and my heart, so we just tried everything back then."

Although Heidelberg will always have a special place in his heart, Scotty76 has been drawn to Stuttgart – to paint in Bad Cannstatt. "As a newcomer, I didn't really belong anywhere at the start, but through breakdancing and graffiti I suddenly had respect all over. Everyone on the scene knew who I was. It really meant a lot to me," reminisced Scotty76, as we headed towards König-Karls bridge in the Porsche in the early evening.

This is the home of the first *Hall of Fame* in Stuttgart, a place of pilgrimage for hip-hop fans.

Stuttgart 48° 47' N 09° 11' E

⚲ PLACES TO GO & DRIVE

Hall of Fame Bad Cannstatt
Iconic graffiti area.
König-Karl-Straße
70372 Stuttgart

StadtPalais – Museum für Stuttgart
Museum on the history of Stuttgart.
Konrad-Adenauer-Straße 2
70182 Stuttgart

Schräglage
Hip-hop club.
Hirschstraße 14
70173 Stuttgart

Jugendhaus Mitte
Creative venue for all young people, and those young at heart, in and around Stuttgart.
Hohe Straße 9
70174 Stuttgart

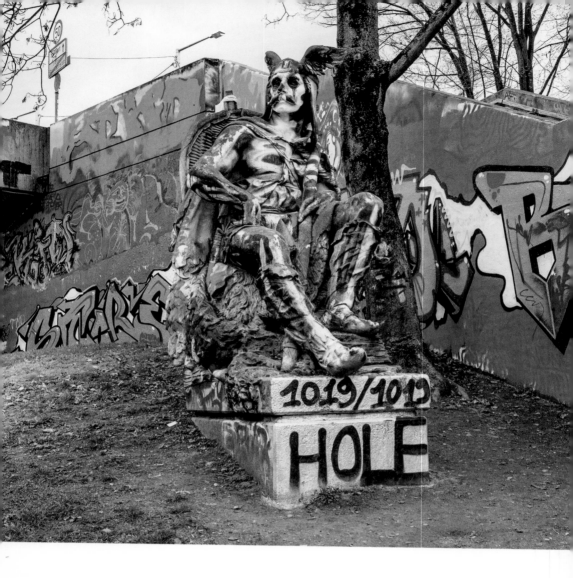

A place of pilgrimage for hip-hop fans.

Hall of Fame is how graffiti writers colloquially refer to a wall surface that they practice on, that they spend a lot of time on for elaborate productions, sometimes alone, sometimes as a crew. The term comes from the USA, where the first of its kind originated at the place where 106th Street meets Park Avenue in the New York neighbourhood of East Harlem in 1980. In Germany, the Berlin Wall later became an iconic image of spray-painting concrete.

Here, on the site of the "Canstatter Wasen", graffiti is totally legal, and explicitly wanted and

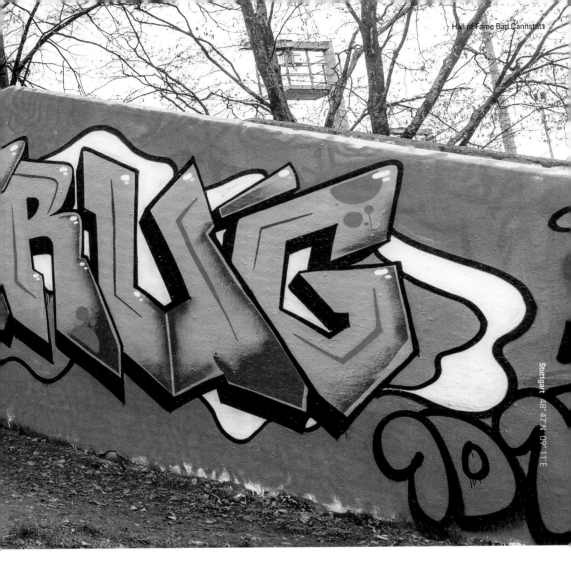

Stuttgart 48°47'N 09°11'E

requested by the city and initiatives. Spraying is part of the cityscape there and, like in Copenhagen and Barcelona, is part of the culture. Stuttgart's visible proof of their love of hip-hop. And yet there are differing approaches to graffiti, as is so often the case in European urban design. The borders between illegal surfaces and legal spaces are fluid, the city regularly carries out clean-up operations and actively seeks dialogue with those on the scene.

The best example is the sculpture *Der Wehrstand* by sculptor Adolf Fremd, which stands at the entrance to the *Hall of Fame*. Its resemblance to the famous Gaul has seen it dubbed *Asterix*, as Scotty76 explained. Although spraying the statue is prohibited, some artists experiment on it regularly. And the city allows this creative collaboration. For Kolchose, for creative collaboration. As they say in the metropolis: **it's not where you are, it's what you do.**

Foreign in My Own Country

Hip-hop culture has always contributed to greater understanding, openness and integration. With its core values, it is the polar opposite to racism, hatred and exclusion. In 1992, the Heidelberg-based rap pioneers *Advanced Chemistry* put the issue of xenophobia in Germany on the agenda. This was the start of a movement that has always stood up for a better coexistence, making it one of a kind.

Declaration of war on everyday racism.

In the summer of 1992, hatred took a hold of Germany. It was less than two years since the reunification when neo-Nazis in Rostock-Lichtenhagen attacked the central refugee shelter and an apartment block housing former Vietnamese contract workers. 3000 people looked on, applauded and impeded the police and emergency personnel, while right-wing radicals hurled Molotov cocktails at the apartment block, known as Sunflower House, which still housed more than a hundred people at the time.

– "I have a green passport with a golden eagle on it." –

It was with these lyrics that German-Italian Toni-L, German-Haitian Torch and the rest of the Heidelberg crew *Advanced Chemistry* created a symbol for a free Europe and against racism. Hip-hop raised its voice like no other. In the same year, the year in which Germany experienced the worst right-wing riots in its post-war history, Advanced Chemistry was instrumental in shaping the sound, culture and self-image of German rap history, which was still very much in its infancy, combining politics, message and style with an urban youth culture.

"Let's admit it, that song was anything but commercial," recalls Toni-L, roughly 25 years later. He was born and raised in Heidelberg, from where he has shaped German hip-hop culture as a pioneer. The former B-Boy has a legendary air about him. To this day, he still lives in the university town on the Neckar. He is a passionate stage actor and a welcome guest at cultural events in his hometown.

Back in 1992, MTV played *Fremd im eigenen Land* (Foreign in My Own Country) throughout Europe, despite the lack of commercial character and the tough political message. Or perhaps for precisely that reason. It was a signal that made the international musical landscape sit up and listen – and subsequently elevated *Advanced Chemistry* to the status of rap legends. It was clear to many at the time, "that a new Germany was being shaped," says Toni-L today.

The riots in Rostock-Lichtenhagen were one in a chain of many assaults and racist attacks perpetrated by neo-Nazis on foreigners. After the reunification, Germany showed its ugly face. The German government reacted to the violence – however, not by cracking down on the hatred, but by tightening asylum law. The vast majority of the Vietnamese affected in Sunflower House were later deported.

The group around Torch and Toni-L heard of the events whilst working together in the studio on new recordings – and used *Fremd im eigenen Land* to take stock of their experiences and express their emotions. Comrade-in-arms Linguist has his roots in Ghana, Gee One is Chilean. Together with DJ Mike MD, they utilised the song to broach the issue of everyday racism, the harassment and marginalisation they themselves were experiencing at the time, because their life story, appearance, family background or name did not fit in with a supposed German identity:

– Not recognised, foreign in my own country, not a foreigner, and yet still foreign –

Deeply rooted in Heidelberg, *Advanced Chemistry* has been more than just a rap crew since it was formed in 1987. It is rather an integral view of hip-hop culture, which is still in its infancy in Germany – its diversity, love and openness. The group has become a mouthpiece for a youth culture, which, as well as rap, also incorporates DJing, breakdance, a different style of clothing, and graffiti. Back in the mid-1980s, Torch was freestyling at jams in German. To this day, the whole crew is seen as being very cultural and closely associated with hip-hop values.

At that time, Heidelberg became a Mecca of hip-hop culture, which also played home to Cora E., the Stieber Twins and Boulevard Bou over the following years. Influenced by American conscious rap and the Native Tongue movement, the central themes on the Neckar were often politically and intellectually motivated, and always driven by the common movement for love, peace and freedom.

Back then, many people felt that the song spoke to them, Toni-L recalls. "Unfortunately, this issue is more topical now than ever," he said during a visit to a bridge in Heidelberg for *Back to Tape* – the same bridge that served as the backdrop for the music video to their famous track. One thing is clear today: since *Fremd im eigenen Land*, hip-hop has been political and the commitment to tolerance, integration and helping disadvantaged and marginalised groups is firmly anchored in its DNA.

Times are changing ... not

In 2000, three drunk neo-Nazis in Dessau beat up Mozambique-born Alberto Adriano in a town park. The 39-year-old died of his injuries three days later. In the same year, Adé Bantu, Torch and D-Flame launched the Brothers Keepers project as a reaction to the increasingly dangerous everyday reality experienced by many people with foreign family backgrounds. One year later, the project, which enjoyed the support of many big names on the hip-hop scene, released the song *Adriano (Letzte Warnung)*. In doing so, it raised and revived the same criticism as *Advanced Chemistry* did 19 years ago. In 2018, Samy Deluxe rapped the following lyrics during his SaMTV Unplugged performance on the Hamburg museum ship MS Bleichen:

**– "As a child already realised:
I am foreign in my own country,
Operation Article 3, you laughed." –**

Article 3 of the Basic Law states that all people are equal before the law. *Brothers Keepers* used proceeds from their concerts to help victims of extreme right-wing violence. Heidelberg hip-hop institution Toni-L is also a member of the group. Over the following years, musicians like D-Flame, Afrob and Megaloh also regularly highlighted their experiences of racism in their songs.

As a way of opening the door to youth, many of them also used hip-hop culture within school and aid projects. Samy Deluxe formed the organisation "DeluxeKidz e.V.", which is also supported by Christian Delles, aka Beat Boy Delles. He is a Hamburg institution, who has been breakdancing and painting graffiti since 1990. The goal: to give young people alternative recreational activities – an alternative to smartphones, PC games, television and social media. The organisation lives and breathes cultural diversity. It views diversity as strength, and hip-hop as practiced integration.

After the attacks on Alberto Adriano, the commitment to tolerance and human rights remained a perpetual theme in many songs by big names on the German rap scene. Hip-hop styles changed, as did the names of the artists. New hip-hop and rap strongholds emerged across the republic, in Stuttgart, Hamburg, Munich, Frankfurt, and Berlin. The social challenge remained. In 2014, Eko Fresh, a German rapper of Turkish descent, wrote: "Zehn Menschen tot als die Behörde scheinbar schlief. Irgendwie fies, dass man danach was von Dönermorden liest." (Ten people dead as the authorities seemed to sleep. It's somehow disgusting that you then read of kebab murders.)

"Kebab murders" is the name the media gave the crimes perpetrated by the NSU. Right-wing terror went on to leave a dreadful trail of blood across Germany. Here too, it was hip-hop that provided a voice for the victims and discriminated groups. "Opfer werden Täter, Faschos verschont, Mauerfall bis Nagelbombe, das hat Tradition" (Victims become perpetrators, fascists are reprieved, fall of the Wall to nail bombs, it has become a tradition) – the words of rappers Rapper Refpolk and Kutlu Yurtseven in their song Niemand wird vergessen. Words that pillory the approach and methods of the investigative authorities, who, among other things, suspected the victims' relatives.

Are you awake?

Hip-hop has always been a rallying cry. For social change. For love. For respect. In hip-hop, it doesn't matter who you believe in, where you come from or who you love. It is an appeal, which the scene regularly renews – or, rather, has to renew. For example, in February 2020, when a 43-year-old shot and killed nine people in cold blood in Hanau. He found his victims in a shisha bar, a kiosk and a restaurant, selecting every one of them because they apparently had a migrant background. The perpetrator later shot his mother, before turning the gun on himself.

– "Unity, justice and freedom. Everything we wanted here in this country. Live in peace with each other." –

These lyrics were rapped a few weeks later by Hanau-based musician Azzi Memo. In the eight-and-a-half minute track Bist du wach? (Are you awake?), he once again united the German hip-hop scene: Kool Savas, Veysel, Manuellsen, Credibil were among the 18 musicians who voluntarily got involved, as a matter of course. Without any commercial aspirations. Without fishing for clicks on YouTube, likes on Instagram, or streams on Spotify.

Powerlessness, anger – and hip-hop, as the soundtrack to this peaceful movement
Powerlessness and anger, but also a frustration about everyday racism and confrontations with a police force that is seemingly systematically racist are growing within the urban youth culture of hip-hop. Particularly in the USA. Far from the town of Hanau in the German state of

Hessen, rap beats form the soundtrack to the #BlackLivesMatter movement, which came to a head in 2020 after the violent death of George Perry Floyd Jr. Beyond national boundaries, many Americans are creating a symbol for tolerance and freedom.

Political rap has been creating its own genre since well before duo Public Enemy and its 1988 album Fear of a Black Planet. Alongside the protests, music is an important element of the movement. Back in 2014, Kendrick Lamar's Alright became a hymn for the protestors. The song by the rapper from Compton, Los Angeles, combines a political and critical message with one of hope: We gon' be alright.

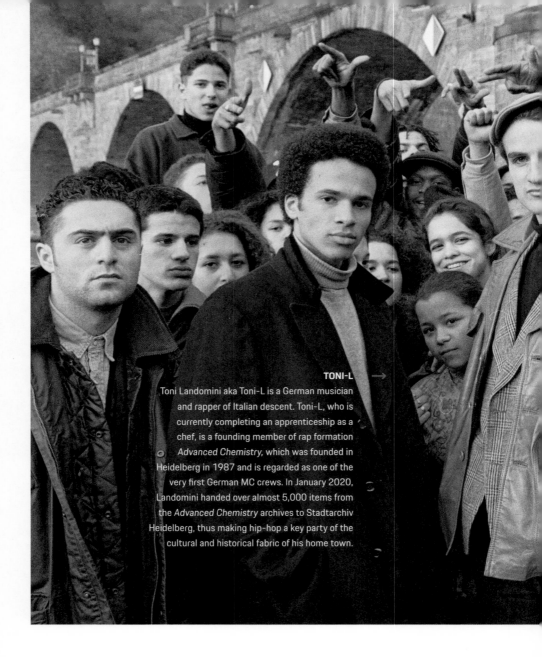

TONI-L →

Toni Landomini aka Toni-L is a German musician and rapper of Italian descent. Toni-L, who is currently completing an apprenticeship as a chef, is a founding member of rap formation *Advanced Chemistry*, which was founded in Heidelberg in 1987 and is regarded as one of the very first German MC crews. In January 2020, Landomini handed over almost 5,000 items from the *Advanced Chemistry* archives to Stadtarchiv Heidelberg, thus making hip-hop a key party of the cultural and historical fabric of his home town.

Rap lines with and about Afro-American protest have a history in the USA. A history that dates back as far as the beginnings of the enslavement and abduction of Africans – and achieved global fame in the collaboration of rap and classical pop music. Not only in the States themselves, but also in Europe. And so it is artists like singer Beyonce Knowles and director Spike Lee who add

strength to the #BlackLivesMatter movement with coverage and, above all, creativity. In doing so, they unite the masses behind one message.

These examples show that hip-hop crews all around the world soak up what is happening around them – in their block, their district, their city, and all over the globe. They rap about these

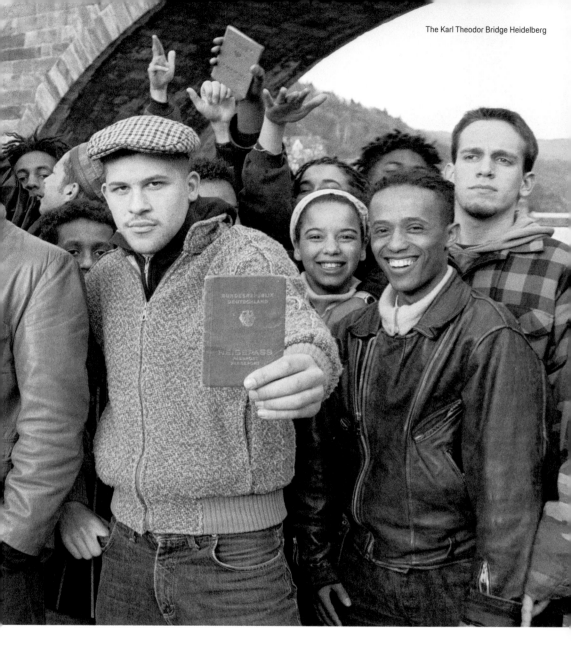

events in their songs. Chuck D from Public Enemy once said that hip-hop is the "Black CNN", a means of disseminating information. What he definitely meant was that, whether terrible images of death, xenophobia and pain are broadcast in the news, or rap texts are explicit and possibly abusive: both portray real events. And so, almost 30 years later, one thing is clear in nearly every corner of the world: the feeling that Toni-L, Torch and their comrades-in-arms in Advanced Chemistry described on the banks of the Neckar in 1992 can still be felt everywhere to this day – the feeling of being "foreign in one's own country". Hip-hop always remains a positive response to that feeling.

Lon don.

London 51° 30' 26" N 0° 07' 39" E

Journalism • Rap

APEX ZERO

For the London music expert, hip-hop is an open, multi-cultural phenomenon. Apex Zero, who co-founded a hip-hop magazine as a journalist in 2012, aims to preserve the central roots of hip-hop: humanity and attitude. His magazine *I Am Hip-Hop* helps former offenders to regain a foothold in normal society after their release.

FORGING ITS OWN PATH

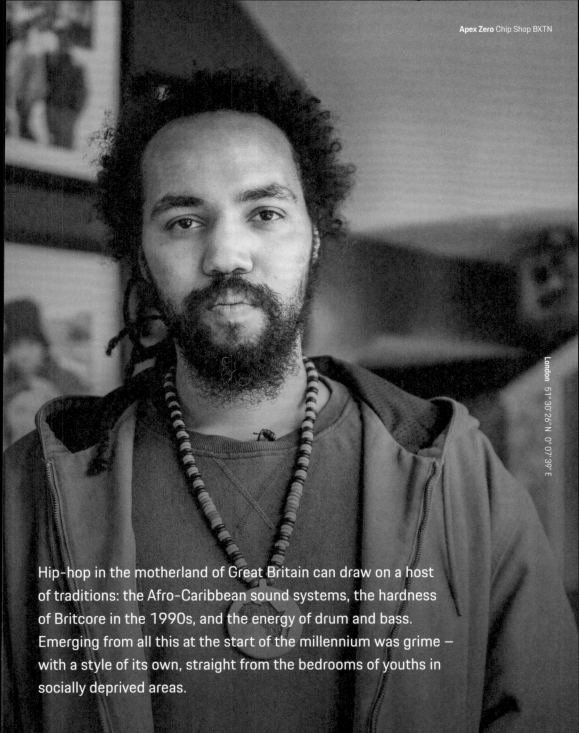

London 51°30′26″N 0°07′39″E

Hip-hop in the motherland of Great Britain can draw on a host
of traditions: the Afro-Caribbean sound systems, the hardness
of Britcore in the 1990s, and the energy of drum and bass.
Emerging from all this at the start of the millennium was grime –
with a style of its own, straight from the bedrooms of youths in
socially deprived areas.

Our visit to Apex Zero, co-founder of the independent magazine *I Am Hip-Hop*, takes us deep into the heart of London's Afro-Caribbean culture. From the musical theatres of the West End and the bars of Soho, our route heads past Buckingham Palace. Having crossed Vauxhall Bridge, we cruise through the area of "Little Portugal" and on to Brixton. Since the beginnings of the independence of the British colonies at the end of the 1950s, many black Commonwealth citizens have flocked to the capital.

They moved into the working-class districts on the southern side of the Thames and created a vibrant community along the Brixton Road, in which the sounds of Jamaica and Trinidad were ever-present. The traditions of calypso and ska were followed by reggae and dub sound systems, which, from the 1980s, absorbed influences from US rappers and DJs to develop their own unique blend.

"Hip-hop is my life," says Apex Zero. "I may have been born and raised in London, but my parents came here from Africa, via the Caribbean. Through my involvement with culture, I encounter ancient lifelines. Music tells me who I am." He recalls the West African griots, the keepers of oral tradition.

London 51° 30' 26" N 0° 07' 39" E

Transfer of words and ideas.

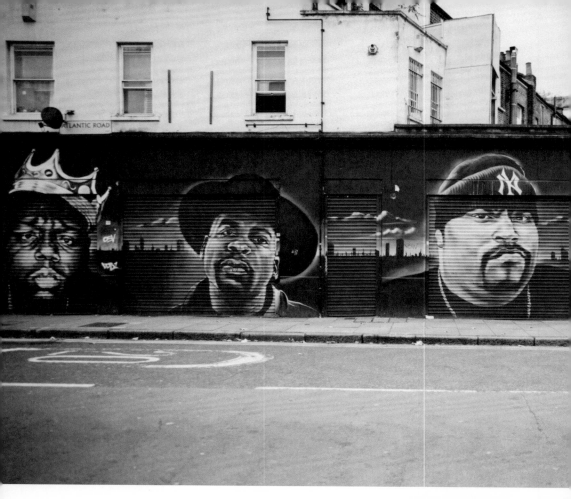

Today, we find similar storytellers in rap. His first major interview for *I Am Hip-Hop*, with the politically active New York duo *Dead Prez*, provided confirmation of the transatlantic transfer of words and ideas. "We agreed that it is all about bringing people together through the original values of hip-hop," he says.

Before his time as a journalist and lecturer, Apex Zero was a member of rap duo *First and Last*, alongside his good friend Omeza. A project tackling the oppression and racism that arose at the big battles in London. He referred to his style as "Neo-Hardcore Hip-Hop", with raw, diversified beats. After the release of his debut solo album in 2013, he presented a broad musical spectrum as the host of various events.

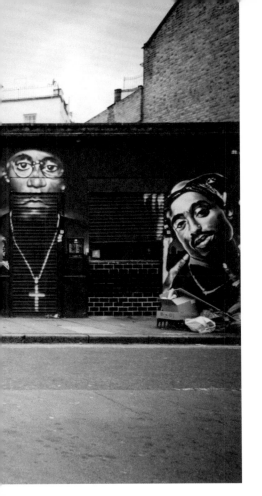

– "We agreed that it is all about bringing people together through the original values of hip-hop." –

With a website, radio programme and regular printed editions, *I Am Hip-Hop* has, since 2012, established itself as an authentic voice of the underground, supported by the charitable organisation No Bounds. This originally offered former convicts an opportunity for rehabilitation. A communal project, which was soon implemented internationally through its digital channels. Genres like UK garage and grime are played on their own doorstep. With Mancunian rapper Zeph and south London's graffiti artist Xavi Art, the unique British way is there for all to see on the hip-hop scene.

London 51°30'26"N 0°07'39"E

📍 **PLACES TO GO & DRIVE**
Everythinghiphop Clothing
Streetwear and skate shop.
Pancras Square
Pancras Rd, Kings Cross
London N1C 4AG

XOYO
Nightclub and event location.
32-37 Cowper St, Old Street
London EC2A 4AP

The broken beats of grime.

We roam through Brixton Market, with its vegetable and clothing stalls, to the nearby Electric Avenue, which was immortalised by Eddie Grant in 1983 with his reggae hit of the same name. The Black Cultural Archive curates events on black identity in Great Britain, in which music often plays a key role.

The United 80 fashion and culture centre, the Diverse shop with art and local designs, and renowned record store Pure Vinyl are typical of the modern Brixton, which has not escaped the gentrification and horrendous rents witnessed in other districts of London.

Apex Zero remarks that, for him, hip-hop has always been a forum for people experiencing social exclusion. Feelings about current realities and fractions would be offloaded in the subgenre of grime, which emerged in London a good 20 years ago. Since then, an increasing number of new crews, in which the rapper is referred to as "MC" (Microphone Controller, in this context of the sound system), have established the style throughout the whole of the United Kingdom.

"Grime is our hip-hop," wrote British music historian Simon Reynolds back in 2005. An ultrafast, electronically-distorted sound, which sounds disconcertingly not-right. "The blurting MC cadences don't flow, the gap-toothed, asymmetric grooves seem half-finished and defective," said Reynolds.

⚲ **PLACES TO GO & DRIVE**
Black Cultural Archives
National heritage centre for black history.
1 Windrush Square
Brixton SW2 1EF

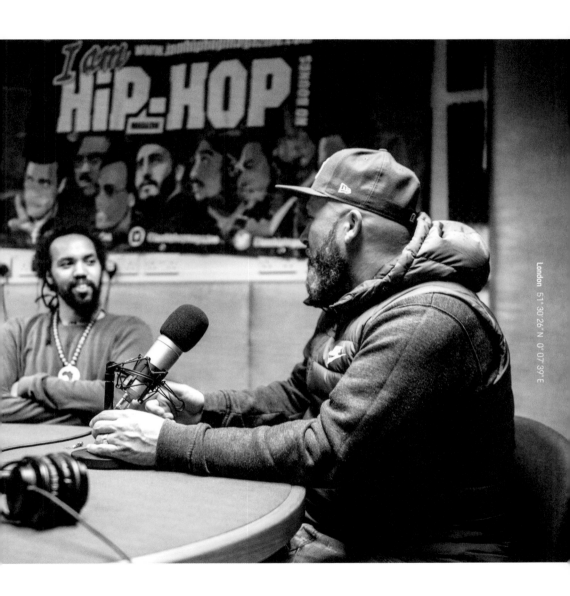

London 51° 30' 26" N 0° 07' 39" E

Rough Trade East

Record store, live acts and coffee shop.
Old Truman Brewery
91, Brick Lane
London E1 6QL

Queen of Hoxton

Open mic hip-hop nights.
1 Curtain Road
London EC2A 3JX

of Black British History

...uralarchives.org

...ery | education | events | cafe | shop

...caheritage

London 51° 30' 26" N 0° 07' 39" E

to differentiate itself from its US role models since the early 1990s. The result was the harder Britcore sound of bands like Hijack, Hardnoise and Silver Bullet, while the reggae roots were still there for all to hear with the *London Posse*.

This all culminated in a technical do-it-yourself culture, in which young rappers in their meagre tower block apartments started to transform their own attempts at rhyming into home-made beats, with the help of low-cost production software. Cheap and quick underground productions, the likes of which were once found on the punk scene. In the meantime, computers are replacing guitars. Supported by pirate radio stations, grime pioneers like *Roll Deep* and the *Nasty Crew* were able to establish a regional fan base.

We grab a take-away from "Chip Shop BXTN" on Coldharbour Lane, a fish and chip restaurant in a hip-hop style, with graffiti, photos, album covers and regular open mic nights for newcomers. Apex Zero explains that it was a long road to establishing grime.

The Jamaican tradition of the sound system developed into a dancehall style, and from there to jungle, drum and bass, and 2-step. The reggae past could only be heard in individual samples. The beats produced by DJ teams like *Kemistry & Storm* floundered intensely in a fantastic cadence. The quick changes in rhythm were celebrated among the audience with gas horns, whistles and bursts of fire from spray cans.

On the other hand, the early British hip-hop sound, with rapper Derek B and female stars like Monie Love and Cookie Crew, had been looking

Tracks were released in limited numbers on CD mixtapes or acetate records — so-called dubplates. The Internet, with its MP3 downloads, would soon take over distribution. An independent style had arisen from the continuous musical exchange.

Diverse fusion.

It was the godfather of grime, Wiley, who, having formed the *Roll Deep Crew* along with a group of MCs in 2002, landed a huge club hit with *Wot Do U Call It*. In 2003, former bandmate Dizzie Rascal won the official Mercury Music Prize, presented by the British music industry, for his album Boy in Da Corner. The British hip-hop underground had suddenly arrived in the mainstream with its raw, aggressive and often dark sound.

Dizzie Rascal was now faced with the question of how far he should move towards pop music, or whether he should continue on the hard grime scene. He opted for a middle road and welcomed producer DJ Youngstar on board. For the key 2004 song *The Dream*, which dealt with his rise out of precarious circumstances, the new team used a musical chorus, which punk impresario Captain Sensible had once used in *Happy Talk*.

— **"Hip-hop is always under pressure from pop culture and the music industry, even though it is revered around the world. There will always be a battle for the real significance of its culture,"** —

DIZZEE RASCAL →

Dylan Kwabena Mills, aka Dizzee Rascal, is one of the most successful rappers from the UK. A native of the East End of London, this artist has appeared on stage with music greats such as Justin Timberlake, the *Red Hot Chilli Peppers* and the *Arctic Monkeys*, among others. He performed his song *Bonkers* at the opening ceremony of the 2012 Olympic Games in London. At the age of 19 he became the first rapper ever to receive the Mercury Music Prize.

says Apex Zero. This applies, in particular, to grime. While Rascal still maintains his role as the *elder statesman* of the movement to this day, colleagues like Skepta, with the single *That's Not Me*, continued to evoke the spirit of the street culture in the mid-2010s. The international link to US stars like A$AP Rocky and Wizkid from Nigeria made grime a global issue.

By the time Dizzie Rascal was awarded the MBE ("Member of the British Empire") for his services to culture, the new grime generation was already in full swing. Stormzy, AJ Tracey and Ms Banks from the southeast of London bring with them new life experiences. "Any time I fall too deep, Always end up back on my feet", Ms Banks evokes a sense of female power. The eternal struggle on the route to the top remains relevant.

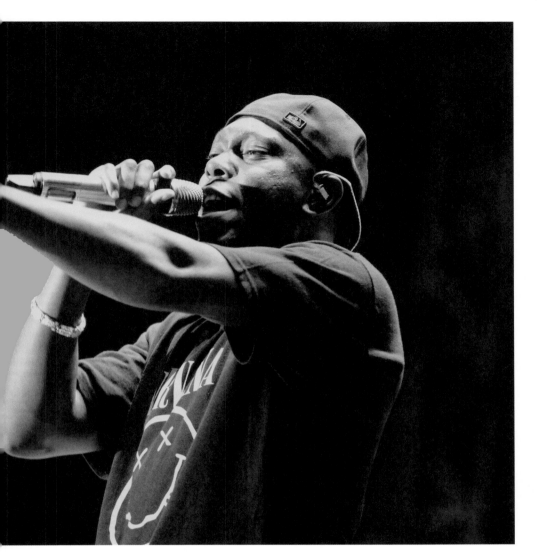

London 51° 30′ 26″ N 0° 07′ 39″ E

A new generation is shaping London.

Consumption details

Porsche Cayenne S Coupé (as of 3/2021)

Fuel consumption, urban: 12.8 l/100 km

extra-urban: 8.2 – 7.9 l/100 km

combined: 9.9 – 9.7 l/100 km

CO_2 emissions combined: 225 – 222 g/km

Co
pen
ha
gen.

Copenhagen 55° 40' 34" N 12° 34' 06" E

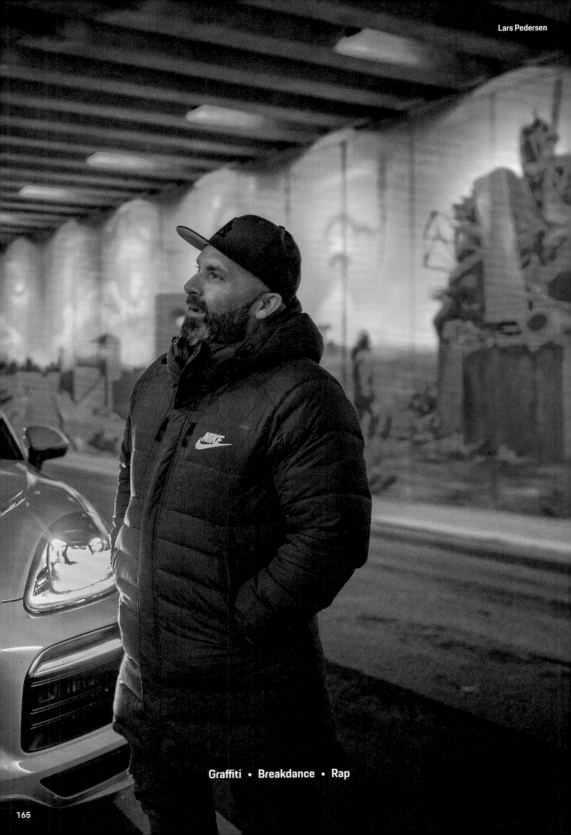

Graffiti • Breakdance • Rap

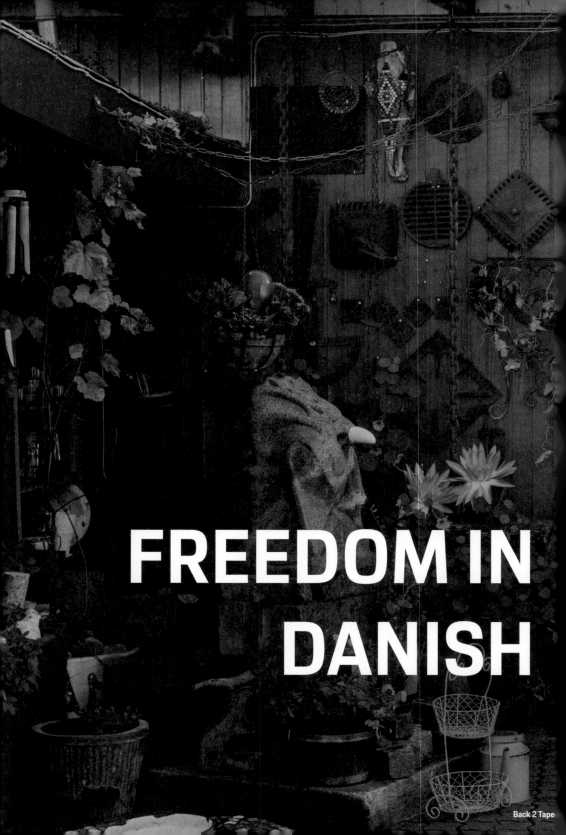

FREEDOM IN DANISH

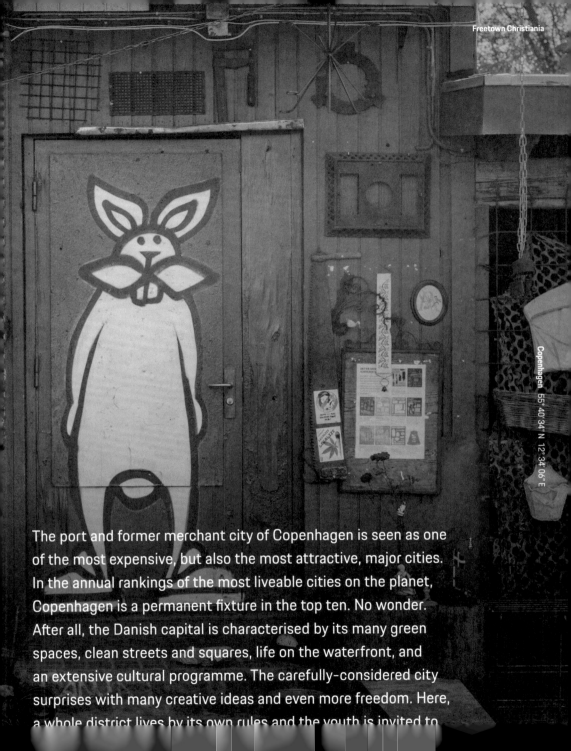

The port and former merchant city of Copenhagen is seen as one of the most expensive, but also the most attractive, major cities. In the annual rankings of the most liveable cities on the planet, Copenhagen is a permanent fixture in the top ten. No wonder. After all, the Danish capital is characterised by its many green spaces, clean streets and squares, life on the waterfront, and an extensive cultural programme. The carefully-considered city surprises with many creative ideas and even more freedom. Here, a whole district lives by its own rules and the youth is invited to

SUNE PEJTERSEN →

Born in Flensburg and Danish by choice, Pejtersen
is co-organizer of underground breakdance event
Floor Wars, which is a central part of the hip-hop
movement in Copenhagen, an event by B-Boys,
for B-Boys. For Pejtersen and his colleagues,
Floor Wars provides a platform for encounters
and thus reflects what this culture can mean in
terms of respect, integration and international
understanding without borders.

A symbol for open-mindedness, and battles in the middle of the crowds.

Freetown Christiania is an extraordinary attraction. The alternative residential area, with ramshackle houses, galleries and event venues for every type of music, is located in the east of Copenhagen, on the banks of the Honsebrolobet canal, not far from the harbour. The autonomous district has existed since 1971 on the site of a former military barracks. The residents live by their own rules, entirely legally, with the approval of the Danish government. Mutual inspiration and respect are the cornerstones here – just as they are in hip-hop.

Copenhagen, and Christiania in particular, is the second home of Sune Pejtersen. As a child, the beatboxer, guitarist and dancer used to dream of life beyond the borders of his North German birthplace – Flensburg. He tells us that he first watched Beat Street in the cinema at the age of twelve. The classic film portrays life in the Bronx, a borough of New York decimated by gang wars, and how the people there rise again.

"With the help of hip-hop and, in particular, breakdance. Hip-hop is of similar importance to the subculture here in Christiania. Maybe it even gives it the stability required in this kind of anarchy. When I arrived here in the late 90s, and people suddenly started breakdancing at a party, I was blown away," Sune raves.

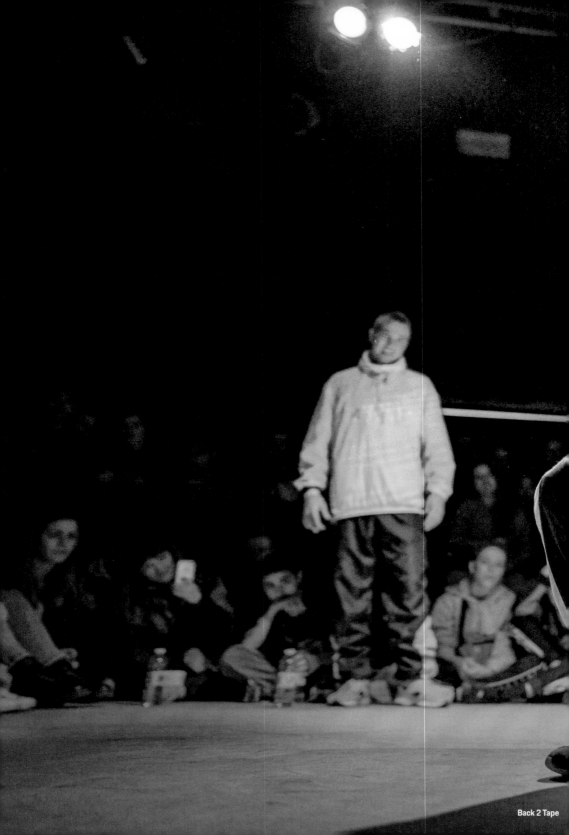

Back 2 Tape

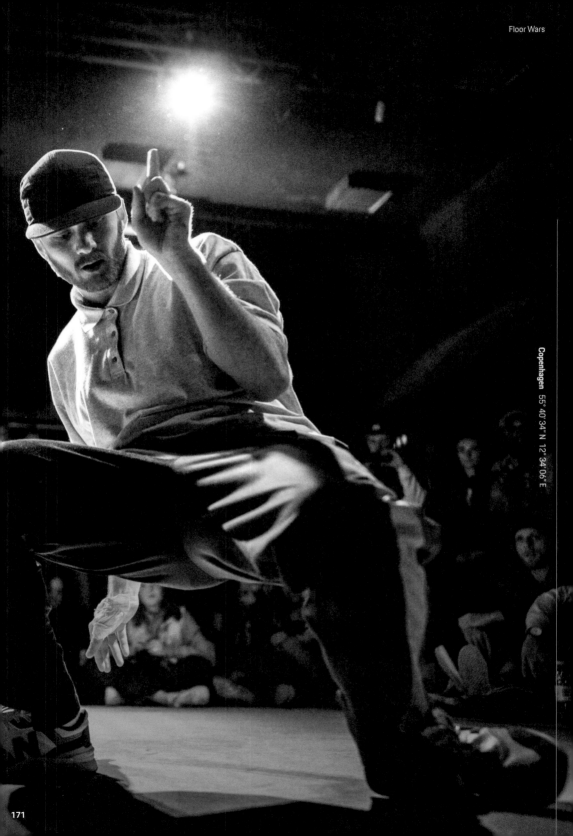

Copenhagen 55° 40' 34" N 12° 34' 06" E

One of the things he finds so fascinating about Christiania is the unbridled creativity and, thanks to the many visitors from the world over, the international exchange of ideas. "Christiania has become a real magnet for breakdancers from all over the world. Dancers who have never been to Europe come here from America, Congo and Korea," says Sune, enthusiastically. "Christiania is the symbol of free thought in Denmark. The hip-hop culture here is extremely vibrant," says the Copenhagener by choice.

Just a few metres from Christiania, Sune Pejtersen created the *Floor Wars* breakdance festival in 2005. Since then, it has retained its original underground character: the so-called battles do not take place on a stage, as is more conventional, but on the ground in the middle of the crowd. A kind of ring. The Copenhagen colosseum, only closer to the audience.

"This proximity to the crowd is very important to Floor Wars," he explains. For Pejtersen, it is essential that his series of events remains one that was made by B-Boys for B-Boys. *Floor Wars* is a place for artists to meet and, as such, reflects the significance that this culture can have:

– "Hip-hop contributes more to international understanding and union than politicians ever could," –

believes Pejtersen. It cannot be disputed that breakdance has played an important role in hip-hop culture for many years. The fact that Copenhagen has become a Mecca for breakdancing is another surprise.

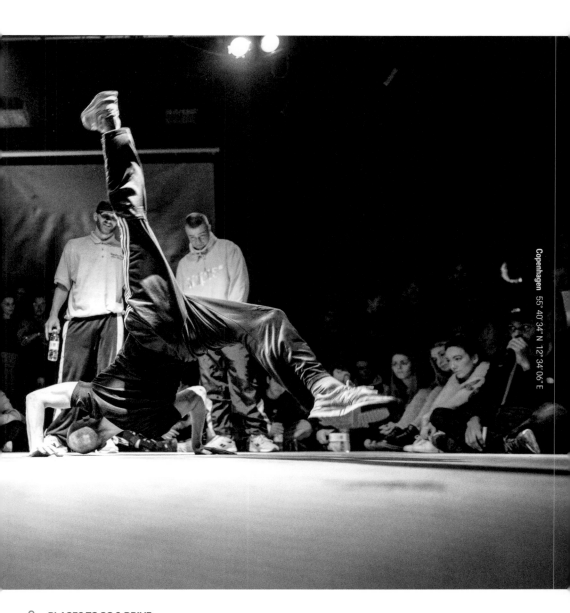

Copenhagen 55° 40' 34" N 12° 34' 06' E

♀ **PLACES TO GO & DRIVE**

Freistadt Christiania

Alternative residential and creative settlement.

Prinsessegade

1422 Copenhagen

Reffen Copenhagen Street Food

Urban playground for street food and creativity.

Hal 7 & 8 Papirøen, Trangravsvej 14, 7/8,

1436 Copenhagen

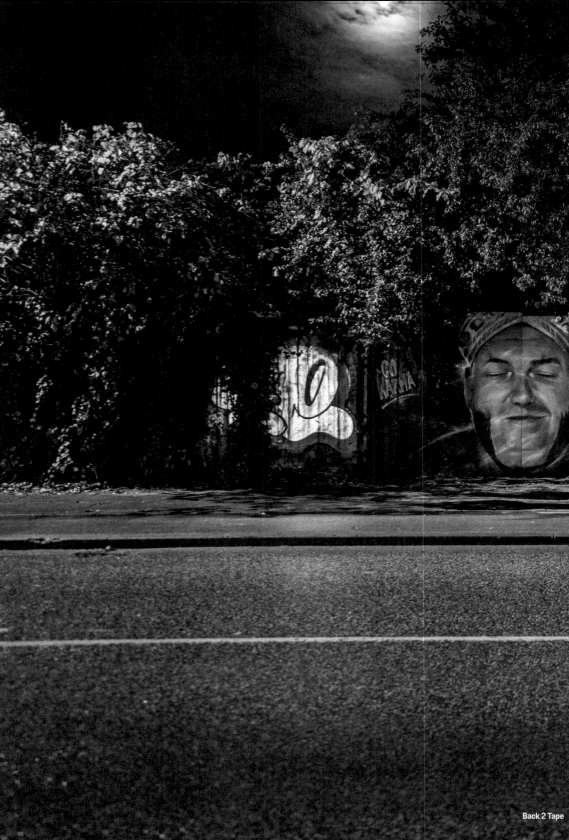

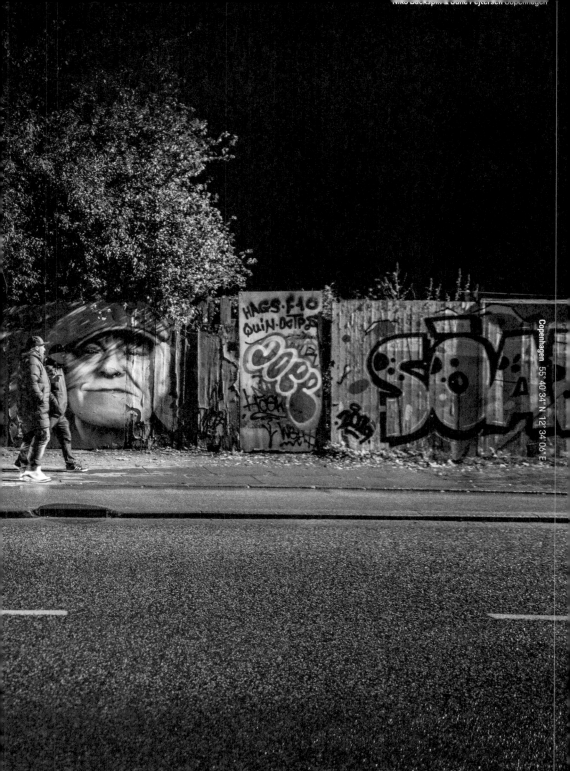

Copenhagen 55° 40' 34" N 12° 34' 06" E

We drive along the canal towards Sydhavn. This is a place bustling with activity: diggers and cranes work industriously on the redevelopment of the port area. A little later, we are looking into Lars Pedersen's face.

He has already had a lasting impact on the Danish capital, with the Evolution Wall. The graffiti wall can be found at the Enghave Brygge subway station. Located to the south of Fisketorvet, this area of Sydhavn is a special place. Plenty of water and the proximity to the bustling district of Vesterbro and Amager, a virtually unspoiled stretch of idyllic seaside.

Impressively emblazoned across the Evolution Wall, a 470-metre length of concrete, is the history of the earth. From the big bang to the present day. As colossal graffiti. Officially commissioned by the city of Copenhagen, curated by Lars Pedersen.

LARS PEDERSEN

Lars Pedersen is a European graffiti legend and hip-hop to the core. Pedersen developed the Roskilde Festival far beyond the borders of Denmark, turning it into a Mecca for breakdancers and street artists and establishing contacts all over the world. His works from the Institute of Urban Art, which he founded together with Peter Skensved, can now be seen in more than 40 countries. The 470 meter graffiti work on the history of mankind in Copenhagen, curated by Lars Pedersen, is one of the most important hip-hop locations in Europe.

Copenhagen 55° 40' 34" N 12° 34' 06" E

The evolution of humankind in 470 metres.

Works from the "Institute of Urban Art", which was founded by hip-hop journalist Peter Skensved, can be seen in more than 40 countries. However, the Evolution Wall is something very special for both Pedersen and Skensved. Maybe because it is on their home soil. But perhaps also because the project was such a challenge.

As they walk alongside the wall, they both recall those challenges:

– "You try coordinating six free-spirited graffiti artists from all over the world, whilst at the same time getting them to work in a predefined framework," –

says Pedersen, grinning broadly. "The city did give us enough freedom to interpret Evolution as we wanted, but it was certainly a special act. The length of 470 metres and the different nationalities of the artists were a challenge in their own right," Skensved recalls.

Networking is a skill that both possess. It is their secret formula. "Over the years, I have built up a large network. I enjoy meeting people, chatting to them and bringing them together when appropriate," says Pedersen, who also curates the Roskilde Festival. With up to 115,000 visitors, this is one of the biggest open-air festivals in Europe.

"I have also often driven to Germany, and have met many friends and colleagues – and what goes around comes around. That inspires me." It is precisely this feeling that I keep getting during my *Back 2 Tape* roadtrip through Europe: freedom and inspiration.

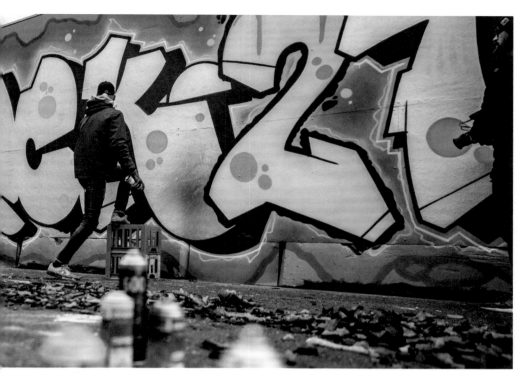

The duo eventually comes to a stop in front of a section of the wall, on which a caveman can be seen. "Just look at that. We have travelled back a good 40,000 years. That caveman is basically the first hip-hopper: he is leaving his message on the walls in ash and blood," explains Pedersen. Hip-hop does, after all, consist of a healthy portion of poetry.

PLACES TO GO & DRIVE

Evolution 2
At 470m, Europe's longest graffiti wall.
Enghave Brygge
2450 Copenhagen

Kødbyen – Meatpacking District
Creative cluster of galleries, nightlife and cafés.
Flæsketorvet
1711 Copenhagen

Amager Beach Park
Coastal area, Mecca for skaters.
Amager Strandvej 110
2300 Copenhagen

Run for Cover
Record and streetwear shop, graffiti supplies.
Hvidovrevej 80A
2610 Rødovre

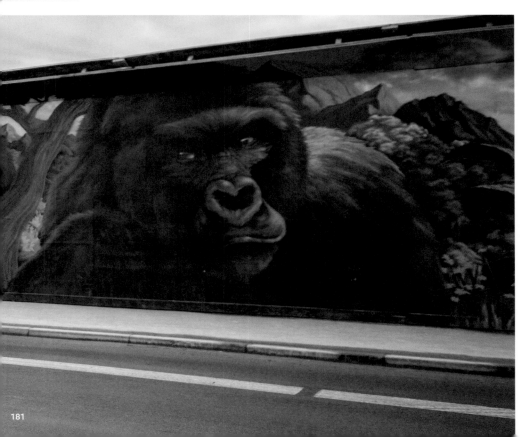

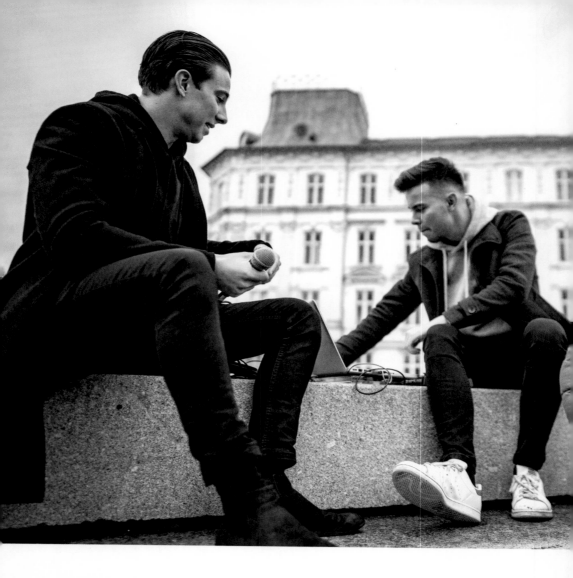

Copenhagen is surprisingly a hotspot for hip-hop fans. We meet another two faces of the city where their careers began: on the streets. Armed with a laptop, creativity and a very special beat, brothers Mads and Mathias are the duo *Gebuhr*.

They began making music at the age of just 12. At 14, the first dance sounds started to emerge from producer Mathias's computer.

– "For us, it has always been about creating something that didn't exist before," –

•)) **Back 2 Tape Spotify Playlist**
Sad Soul Gebuhr

← ***GEBUHR***

Together, brothers Mads and Mathias form the young Danish rap duo *Gebuhr*. Influenced by sounds from the USA, these newcomers were already producing in their bedrooms at the age of 12, traveling around the world, mixing college sounds with thoughtful tones and now shaping the new beat of rap culture in Copenhagen.

Copenhagen 55° 40' 34" N 12° 34' 06" E

Beat brothers.

says Mads.

The first singles followed, always shaped by global influences. The songs were characterised by a deep bass in a style verging on American, while the rap was international and not at all typically European: somewhere between fresh college hip-hop with good vibes and, on the other side, reflective, deliberately melancholy. Their song *Sad Soul* has been streamed well over a million times. The newcomers have laid the foundation for future success.

For the next beat, Mads and Mathias take Gebuhr to Hollywood, produce from their hotel room there, soak up the sounds of California, and reinvent themselves. They then bring this new beat back to Copenhagen – onto the streets. To a European Mecca of hip-hop.

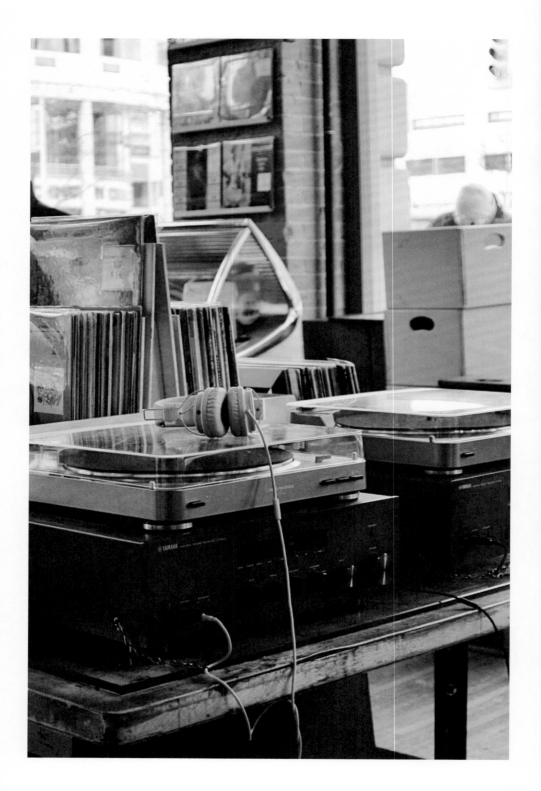

The sound of Europe

Hip-hop originally comes from the USA — the streets and clubs of New York City, to be precise. However, Europe has long since integrated it into its own culture. From grime sound to Atzen pop, from Afro Trap to Austro Rap — the European continent has loved and lived hip-hop for going on 40 years. However, the origins of this, well, mother of viral pop phenomena can primarily be found in Europe's largest cultural markets: Great Britain, France and Germany.

Hip-hop in Europe not only has a precise birth date, but also an exact birthplace: Mainz, on 7th April 1983. It was on this Thursday evening that the hip-hop film Wild Style — now an iconic piece of cinema — was premiered in Germany as part of TV station ZDF's "Das kleine Fernsehspiel" series, which broadcast films by young film and television directors. In fact, this was the first time that the work had been shown outside the American continent, even before it was aired at cinemas in Germany and Europe. One of the reasons for this: the ZDF editorial department.

Wild Style and *Style Wars.*

Hip-hop in Europe not only has a precise birth date, but also an exact birthplace: Mainz, on 7th April 1983. It was on this Thursday evening that the hip-hop film *Wild Style* – now an iconic piece of cinema – was premiered in Germany as part of TV station ZDF's "Das kleine Fernsehspiel" series, which broadcast films by young film and television directors. In fact, this was the first time that the work had been shown outside the American continent, even before it was aired at cinemas in Germany and Europe. One of the reasons for this: the ZDF editorial department.

Back in 1983, New York director Charlie Ahearn was struggling to finance his ideas for films about the new youth movement revolving around rap, graffiti and breakdance. As US television companies viewed graffiti as nothing more than a local phenomenon at the time, and thus rejected the project, he acted on the advice of a friend and got in touch with ZDF. Ahearn had heard that the German TV station was interested in American indie films. The public service broadcaster did indeed present him with 25,000 US dollars from the culture and education budget. Ahearn did say that he had also subsequently received financing from other European TV establishments, but he explicitly names ZDF as the key initial support. You could formulate a daring thesis here that German broadcasting fee payers were instrumental in the spread of hip-hop in Europe.

A celluloid business card

Wild Style is first and foremost a feature film. It revolves around the self-discovery of young graffiti artist Zoro, who is striving to find a way between his civic life as Raymond and his artistic drive as a graffiti writer. It is a coming-of-age story, which consciously combines fiction with real settings and actual protagonists from the scene. As well as leading actor Lee Quiñones, who was himself a graffiti artist by the name of LEE, guest appearances were also made by Grandmaster Flash, and Grand Master Caz's rap crew *Cold Crush Bros*. The result was a cinematic fusion of rap, graffiti and breakdance. Although the term "hip-hop" never actually appears in the film, *Wild Style* was the first moving-image evidence of this youth culture and, at the same time, a celluloid business card that was passed around the world.

"That was the first time I had ever seen graffiti," said Munich-based Loomit, who was one of the first generation of graffiti artists in Germany and was involved in the first wholetrain in Germany. His British counterpart Pride, who in the early 1980s formed the first cross-border writer crew between Great Britain and France with Mode 2 and others, and French graffiti pioneer Bando recall the fascination that *Wild Style* held. Sure, today's graffiti purists may prefer to refer to the equally iconic 1984 documentary *Style Wars*, or the professionally-produced feature film *Beat Street* from 1985, but Wild Style is undeniably the start signal for the hip-hop train to roll across Europe.

Disco, rap and breakdance

While a self-sufficient movement had secretly formed in the hip-hop motherland of the USA, hip-hop had to take a very different route in Europe – in newspapers, on the radio and on television – until it was able to develop into what is nowadays familiar as the biggest youth culture in the world. In the early eighties, youths across the whole of Europe were bitten by the hip-hop bug. The first global rap hit, *Rapper's Delight* by *The Sugarhill Gang* – marketed more as a fun disco tune in 1979 – had long since been copied musically. Spin-offs, like the parodies *Rapper's Deutsch*, which TV presenters Thomas Gottschalk, Frank Laufenberg and Manfred Sexauer performed on German television in 1980, and Chip Shop *Wrapping* by *Allen & Blewitt* from Great Britain, showed the impact that hip-hop was already having on European pop culture. DJ Dee Nasty from the Parisian commune of Bagneux, who went on to record the very first raps in French and was one of the first representatives of the Zulu Nation in Europe, was also inspired by Rapper's Delight. In the following years, more US rap songs like *The Message* by *Grandmaster Flash & The Furious Five*, and *The Breaks* by Kurtis Blow, were released and enjoyed chart success in Europe. However, they were seen more as the result of an entertaining fad

emerging from the disco wave. Hip-hop and rap was initially no more than a gimmick in Europe.

For this reason, the first pan-European rap hit from this period did not come from France, Great Britain or Germany, but from Austria. Inspired by funk legend Rick James' *Superfreak*, Viennese avant-garde artist Falco released *Der Kommissar* in 1982. The song reached the top of the charts in Austria and Germany, as well as Italy and Spain. However, it also made it into the top twenty in the rest of (western) Europe and was re-recorded in many different languages. Ultimately, however, *Der Kommissar* can nowadays only be regarded as a product of zeitgeist, which arose between the end of the disco era and the emerging Neue Deutsche Welle (New German Wave), with influences from *Blondie's The Rapture* and Malcolm McLaren's *Buffalo Gals*. Real rap, from European fans of hip-hop culture, only came about later, as the hip-hop scene did not yet exist – the concept was in the process of emerging.

Breakdance opens the door to hip-hop in Europe

It was ultimately breakdance that flooded the Europe of the 1980s, as an element of hip-hop. Initially presented by the German media as

Breakdance opens the door to hip-hop in Europe.

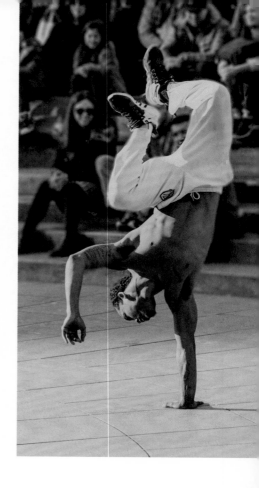

rather awkward and an acrobatic alternative to gymnastics, the dance style from America spread across the entire continent via the popular roller discos of that time.

Breakdance is a collective term for different dances from the Latin-American and Afro-American communities in the USA, and is primarily based on the street dance styles of B-Boying, popping and locking – taught to this day by *Flying Steps* in Berlin. In the aftermath of blockbuster dance films like *Saturday Night Fever* and *Flashdance*, the disco phenomenon was lumped under breakdance for the marketing purposes of the media in Europe. In 1984, youth magazine *Bravo* released a sampler with the title *Breakdance Sensation '84*, which included songs from *Grandmaster Flash & The Furious Five*, and the *Rock Steady Crew*. The magazine also featured a series of photos with step-by-step instructions on how to perform breakdance moves. Similar things were happening in other European countries, which were marketing breakdance as a fashionable phenomenon – for example, the New York City Rap Tour with *Rock Steady Crew* and Rammellzee in France in 1982, which visited Paris, Strasbourg and Lyon, and is now regarded as the initial spark behind French hip-hop culture. In Germany and France, the breakdance trend came to a head between 1985 and 1986, and followed an old hip-hop principle: do it yourself.

Spray can stories

One of the first graffiti works in Europe appeared in Great Britain, courtesy of New York's Futura2000. He was active in France, England and Germany in the early eighties, because a network of gallery owners exhibited his work. As payment for one such exhibition, he received a car, in which he checked out the German motorways, stopping here and there to leave behind an image. A little like an early *Back to Tape* roadtrip. In European cities, it was nothing unusual to use spray cans to paint messages on walls. What was novel was that there were no longer political slogans or demonstrations, but images of a purely aesthetic nature. It was about style, not message. As well as occupying contemporary art galleries, graffiti also spread via structures on Europe's punk scene, as had happened a few years earlier in

New York. The punk scene was an area of culture that was open to unconventional art forms – in Europe too, this meant that hip-hop was "from and for the streets".

Each one teach one

The second hip-hop wave in Europe took place without media attention. Similar to ten years earlier in the Bronx, two components were key to the spread and networking of hip-hop in the late 1980s: railways and graffiti. As the breakdance wave died down, hip-hop primarily spread across the old continent via the spoken word and collective memory. Everything that was documented in any way, whether in newspaper articles or photos, was dug up, collected, archived and passed on – in keeping with the hip-hop principle of "Each one teach one".

This information and impetus travelled from country to country and scene to scene by train – a role that has today been taken over by the Internet and social media. Even during the breakdance boom, contacts were sometimes made through competitions, which often had the character of a sporting tournament. The routes of the European rail network were, in a figurative sense, the central nervous system of the local hip-hop culture. The lifeline of Europe's first hip-hop generation.

Subway images & crazy legs

At the start of the 1990s, European hip-hop activists were primarily left to themselves. At home, they were seen as nerds, which only motivated them to seek out kindred spirits outside their own towns and cities. Hip-hop arrived in Europe as a complete cultural package, which provided an underlying context for graffiti, rap and DJing.
The first generation of hip-hoppers in Europe were all-rounders, who expressed themselves

through rap, breakdance and graffiti. This is one of the reasons that French DJ Dee Nasty, and subsequently German rapper Torch from Afrika Bambaataa, were named as "Zulu Kings" – European correspondents for New York's Zulu Nation. It was also Dee Nasty who organised the first jams and hip-hop meetings in France, which were attended by people from all over Europe. However, this was not a linear narrative or a continual development. Many things were happening at the same time, or at great intervals. The fact that these events brought together people from totally different social classes also came with complications in the early years of European hip-hop.

Hip-hop unites generations.

It was first and foremost graffiti artists who kept alive the spirit of the fledgling hip-hop culture in Europe. For example, Ralf Kotthoff tells in his book *Könnt ihr uns hören? Eine Oral History des deutschen Rap* (Can you hear us? An oral history of German rap) how MZEE founder Akim Walta, aka Zebster, approached people at random at German stations if their dress code smacked of hip-hop – for example, trainers or blotches of paint on their clothes. This basic dynamic stretched from Copenhagen to Paris: the constant search for other members of the family.

The first *graffiti Halls of Fame*, such as the Stalingrad site in Paris or various spots in Amsterdam, became central meeting points for pan-European hip-hop relationships. Hip-hop increasingly took place in local youth centres, defined in Germany by parties. The jam culture

Bring the Noise

The increasing popularity of rap from the USA was also to thank for the fact that structures were taking shape across the whole continent at the end of the eighties. The growing interest in the culture also manifested itself in the fact that LL Cool J, *Eric B. & Rakin*, and *Public Enemy* performed together in large European concert halls, such as the Hammersmith Odeon in London and the Jaap Edenhal in Amsterdam in 1987. From 1988, Europe experienced a small rap boom, from which emerged such groups as *IAM* in Marseille, Gunshot in London, and *Advanced Chemistry* in Heidelberg. All of the above had already been active as breakers or writers. However, European rap was still years from becoming commercial. German rap pioneer Torch describes hip-hop between 1988 and 1991 as a "chaotic talent show". The media dominance that rap enjoys today only developed in the nineties, when the European scenes began to diversify.

Torch makes German freestyle fashionable

Unlike in France, where the internationally successful chansons of the 60s and 70s had contributed to a respectable history of pop in its mother tongue, and the influence of West African immigrants brought a different self-image to rap, in Germany at the end of the eighties it was commonplace to rap in English. In this country, a fastidious concept of cultural caution prevailed: hip-hop came from the USA, so it was "only right" to rap in English, as was done in the country of origin. Similar phenomena could also be observed in Scandinavia and even in the GDR, which acted separately to the west. For comparison: in 1990, the Rapattitude sampler appeared in France, with contributions from Dee Nasty and *Suprême NTM* predominantly in French already. The German sampler Krauts with Attitude was released one year later, with the majority of content still in

was developing, predominantly in regions, in which US soldiers were stationed. It was they who imported rap records – and drove the networking process.

By the end of the 1980s, writers like Bando (Paris), Shoe (Amsterdam), and Loomit (Munich) were known across Europe and were linked together. This had something to do with the appearance of fanzines like In *Full Effect* in Munich and *Hip-Hop Connection* in London. At the start of the nineties, the whole of Europe was teeming with home-made and hand-written magazines.

German. Only when Torch started to freestyle in German at jams in Germany at the start of the 1990s did the German scene begin to think differently.

Apart from Great Britain, where the sound system culture of immigrants from the Caribbean Commonwealth rapidly led to the establishment of an independent stream of rap, the music produced by crews in the rest of Europe was oriented towards the motherland of the USA. The interdependence of hip-hop and the British club scene was exemplified by crews like *The Wild Bunch* from Bristol, from which trip hop band *Massive Attack* later emerged. Great Britain's unique position produced the first intercontinental rap stars, like *Gunshot* and the *Stereo MCs*. The raw, hardcore hip-hop concept of British bands like *Hijack* had a huge influence on the German hip-hop scene and, under the term *Britcore*, contributed sustainably to a European rap image.

A word-of-mouth network

Based on the network of graffiti writers, a self-sufficient scene was in place in Europe by the early 1990s, with events regularly attended by several thousand people. Most of the participants found out about the events by flyer through the post, telephone chain, or in specialist fanzines. In 1990, the cross-border hip-hop jam CH Fresh '90 was held at the Dampfzentrale cultural centre in Bern. Among those appearing on stage were *Advanced Chemistry* from Heidelberg and Frenchman Dee Nasty, as well as the British *Stereo MC's*. By the mid-1990s, smaller events, local parties and jams had become veritable festivals. Such was the difference that the first Battle Of The Year took place in 1990 in Hannover – a breakdance event that went on to become the biggest in the world.

Keepin' it real.

While the solidarity between underground rappers and the established musical industry was a fast and fearless process in England and France, the focus in Germany was initially more on maintaining the underground aspect. Whereas in France the radio and charts from 1990 already featured native rap acts like MC Solaar, the German hip-hop scene largely turned its nose up at its first home-grown rap stars, Die Fantastischen Vier, and their 1992 hit *Die Da!?*, which reached number two in the charts. Smudo, Thomas D, Michi Beck and And.Ypsilon were too nice and too self-deprecating for German hip-hoppers. At this time, Germany was the European hip-hop conscience, with a scene of cultural archivists who continued to associate the movement very closely with its place of origin in New York. This is why the supposed first hip-hop release from Germany – Age Of The Atom by Frankfurt's *Bionic Forces* in 1986 – sounds very much like a rip-off of Afrika Bambaataas Planet Rock and the B-Boy beats from overseas.

The first rap album from Germany also came from Frankfurt am Main, although Raining Rhymes by Moses Pelham was far removed from a German hip-hop approach, with its unmistakable dance element. A lack of understanding and financial interest from the influential record label scouts led to a real phobia of major labels in this obscure landscape. As such, hip-hoppers turned to contacts from the

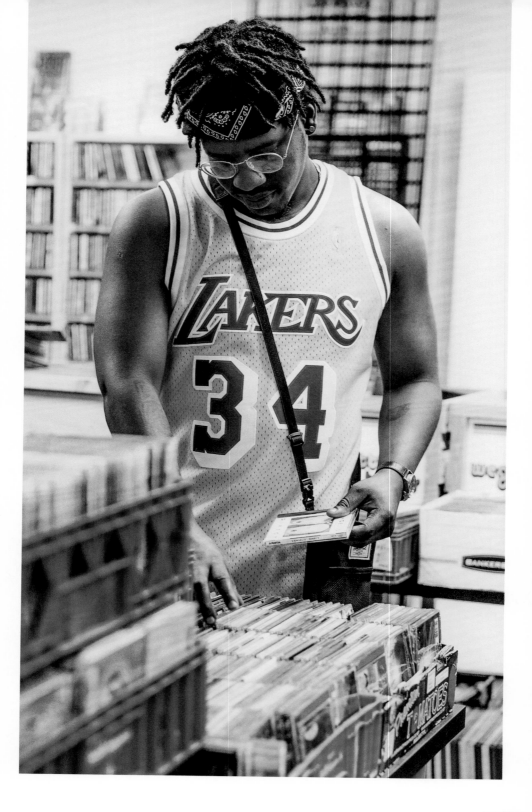

German punk scene – labels like Buback from Hamburg. At the same time, the first independent German rap label structures were founded, led by the Groove Attack record store in Cologne and MZEE Records. The latter released the debut single by *Advanced Chemistry*, entitled *Fremd im eigenen Land*, in 1992.

French rap flies the flag for Europe

As the second generations of hip-hop grew in Germany, France and Great Britain, the social origin of the protagonists became increasingly significant. While the German hip-hop scene consisted predominantly of people from the white middle class, despite a few individual children of immigrants, the hip-hoppers from Paris and London often came from precarious circumstances.

Suprême NTM, one of the most influential rap crews in France to enjoy early commercial success, comes from Saint-Denis, one of the most dangerous suburbs around. This is a social construct that did not appear until far later in German hip-hop. *NTM* are strongly political and produce hardcore rap, a result of the general mood in the poorer districts of France. Their successors *Time Bomb*, made up of Booba's Crew *Lunatic*, continued the political approach. However, their performances became increasingly complex and their language more radical. As a kind of French *Wu-Tang Clan*, they mixed French with other languages, relating strongly to the hard US East Coast rap of the nineties and setting new benchmarks in terms of intonation and flow. The first commercially successful rapper from France, MC Solaar, was musically more oriented towards the Native Tongue movement from the USA, which included bands like *De La Soul* and *A Tribe Called* Quest. With his intellectual, mildly humorous conscious approach, he was closer to what was predominantly pursued in Germany with the second rap generation.

Solaar also ended up on Guru's "Jazzmatazz" album in 1993 and subsequently made a guest appearance with Missy Elliot – putting French rap on the US map in the process.

Sample aesthetic from the motherland, the USA.

The story in the British Isles was a more complicated one. On the one hand, pioneers like *London Posse*, with Rodney P and Derek B, strived to pursue an independent hip-hop approach. On the other hand, rap was also being absorbed by the rave scene, meaning that avant-garde rap musicians like *Stereo MCs*, Tricky and Maxi Jazz from Faithless did rap, but were no longer viewed in a hip-hop context. Labels like BBE and Ninja Tune turned to the sample aesthetic of US rap releases, and then enhanced them – something that subsequently saw DJs and producers like Coldcut and Fatboy Slim's crew *Beats International* no longer categorised as hip-hop, but as having roots in hip-hop. Hip-hop rap artists had a tough time in Great Britain in the nineties, as any overpowering cultural reference to rap's US origins were seen as being too American.

Nordic by nature.

As reasonably professional structures were now also appearing in Germany, with labels like Yo Mama (Hamburg), Ruff'n' Raw (Frankfurt) and Rap Nation Records (Braunschweig), and the first indie magazines were being published, hip-hop started to market itself in Germany. Chiefly through rap. In 1995, Hamburg group *Fettes Brot* made it into the top 20 of the German singles chart with their posse track *Nordisch By Nature*. Moses Pelham and the *Rödelheim Hartreim Projekt* had already enjoyed chart success the year before with Direkt aus Rödelheim. On their ironic album Fenster Zum Hof, which appeared on MZEE Records in 1996, the Heidelberg-based Stieber Twins rapped "Mir wird's zu dumm / zurück zum Minimum" (This is getting stupid / Back to basics) — an alternative plan to clicks, cash and commerce. The big hip-hop boom in Germany landed in 1998 with bands like *Absolute Beginner*, *Freundeskreis* and *Fünf Sterne Deluxe*. Hip-hop had arrived in the German top ten.

French connection

It was a different story for Germany's pioneering neighbours in France. With rappers like Doc Gynéco, rap hit the top of the French charts early on. Whether English with a French accent simply didn't sound cool enough, or the self-awareness of French pop was big enough for rap in French from the word go, hardly any English-language rap was made in France. With the release of the internationally successful film La Haine, with *NTM* rapper Joeystarr in a supporting role, angry street rap from socially underprivileged areas in France became a legitimate element of pop culture in France as early as 1995.

Up until 2001, the influences of French rap in Germany were only sporadic, such as on the first solo album from Frankfurt's Azad. Due to the proximity, and presumably also the increased financial possibilities, efforts were once again made to establish a German-French friendship during the first German hip-hop hype. The *Stuttgart-based collective*, with *Freundeskreis* and *Massive Töne*, featured guest appearances from Shurkin and IAM on their albums. Later on, an entire sampler by the name of French Connection appeared, the concept for which was to unite one German and one French rapper on each track.

With the founding of *Aggro Berlin*, German rap appeared to have been inspired by what its neighbours had achieved. This was expressed, for example, in Bushido's 2003 song *Berlin – Paris* or the clear visual orientation towards French hip-hop videos of Specter, the founder and art director of *Aggro Berlin*. The sound-picture, often theatrical or synthetic, was influenced by German rap of the 2000s, which was gradually freeing itself of the decades of East Coast rap styles with funk samples and jazz influences. With the widespread rise of street rap from Berlin and Frankfurt, German hip-hoppers moved closer, both musically and visually, to the Parisian suburbs than ever before. Hardly any street rap videos produced between 2001 and 2009 were not filmed in black and white in a dreary concrete desert, thus referring either directly or indirectly to *La Haine*.

This development culminated in 2009 in the sampler La Connexion, which, as well as Curse,

Kool Savas and Azad, also featured a contribution from a rapper that was still unknown at the time: Haftbefehl. It was Haftbefehl and his proteges *Celo & Abdi* who, from 2010, definitively translated the French sound into German. For example, Haftbefehl not only repeatedly cited flows and lyrical images from the works of ex-*Lunatic* member Booba, who rose to become a superstar in France in the 2000s, but also clearly refers to lyrics from Parisian rapper Kaaris in one of his biggest hits, *Lass die Affen aus dem Zoo* (Let the Apes out of the Zoo).

European solidarity
Today, European solidarity is omnipresent in hip-hop. It exists beyond borders, language barriers and origins. It manages what politics unfortunately achieves too rarely: to recognise the diversity of the continent as a strength.

The sound of a roadtrip.

Back to Tape
Spotify Playlist

Back 2 Tape
Spotify Playlist

The global rap movement combines technology, fashion and musical innovation. Here are four classics that have had their own stories to tell since the early days.

Hip Hop Icons

Nelson George's seminal work *Elevating the Game* describes the close connection between basketball and black pop culture in the USA. Dynamics, rhythm and coolness are the elements shared by sport and music. Nike designer Bruce Kilgore, who had never designed a basketball shoe before, was the first to exploit this transfer, combining functionality and style. The white master model of the Air Force One became an instant classic in 1982. Moses Malone of the Philadelphia 96ers wore it in the 1983 championships. Old school rapper Kurtis Blow celebrated his Alley Hoops. The white original with the characteristic red swoosh appeared on the cover of the 12-inch *It Takes Two* vby Rob Base and *DJ E-Z Rock*. Rap icons like Rakim, Dr. Dre or Nas celebrate it in their songs. To this day, the Air Force One is a legend that has been produced many millions of times, in dozens of colour combinations.

Nike
Air Force
One.

Roland TR-808.

Hip-hop was still in its infancy when Roland's chief engineer Tadao Kikumoto experimented with synthetic sounds. In 1980, the Japanese instrument manufacturer, known for its drum kits, presented the TR 808. In classic pop music, the black "drum box" with its colourful keys was greeted with scepticism to begin with. It only remained in series production for three years. But for rap pioneer Afrika Bambaataa, their punchy, weird tones were the perfect fit for his vision. In 1983, together with producer Arthur Baker, he combined black music with samples from *Kraftwerk* in *Planet Rock* The 808 delivered the powerful rhythm and thus became the mother of all rap machines. *Public Enemy* or the *Beastie Boys* also later relied on the weird effects and beats. The story is far from over with the use of the 808 in house music and techno.

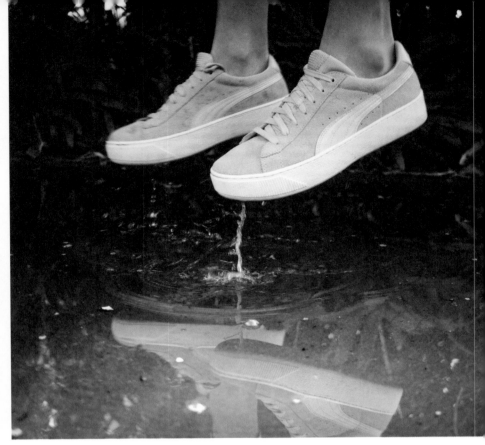

Puma
Suede.

A flat, smooth sole, lightweight material, suitable for wearing on the streets: this classic from the early days of breakdancing is a sports shoe with history. The simple suede model was developed by Puma in Herzogenaurach, Franconia, as early as 1968. Back then, nobody knew anything about the hip-hop block parties of New York's Bronx. At the Olympic Games in Mexico in 1968, the "Suede" worn by world record holder and black power activist Tommie Smith became the icon of his protest demonstration on the winners' podium, a symbol of pride and strength. From 1973 onward, it got another emotional style kick as the professional shoe of choice of legendary basketball player Walter "Clyde" Frazier of the New York Knicks. The B-Boys of the *Rock Steady Crew* and other breakdance formations made it an icon of pop culture worldwide. A perfect mix of street, sport and dance floor.

Technics
SL 1200.

A turntable that has made a place for itself in today's international design museums. The original version was created in 1972, as the developers at hi-fi company Matsushita from Osaka, Japan, responded to the worldwide discotheque craze with constant improvements. A heavy die-cast aluminium housing, solid quartz direct drive, start/stop technology that responds in seconds: this machine allows precision mixing through pitch control, as if it was made specially for the techniques of early hip-hop DJs such as Grandmaster Flash or Kool DJ Herc. Their scratching and beat-matching pushed the possibilities to the extreme. However the "Wheels of Steel" proved to be indestructible and Technics has become the standard model of the global hip-hop community. The successor model 1210 MK2 remained in production well into 2010 – and with the renewed vinyl boom, it will be reissued as a special series.

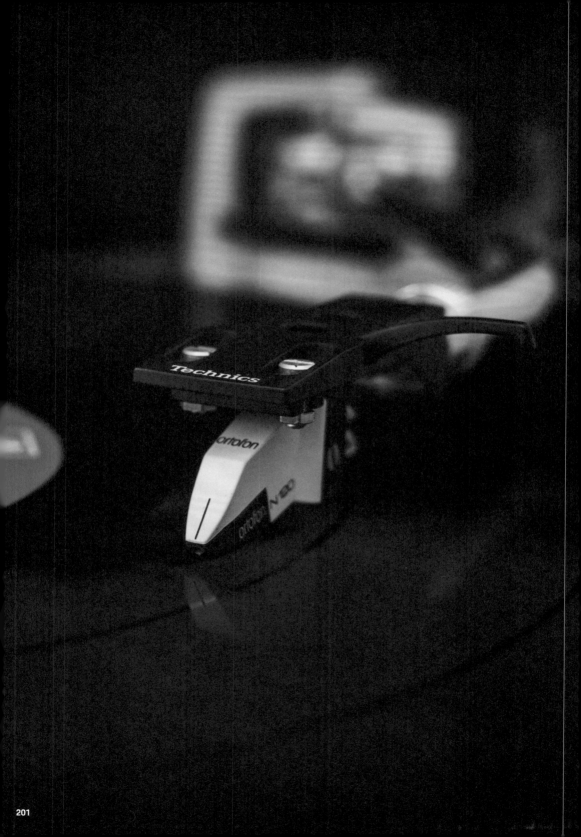

Hip-Hop Glossary

A Adlibs

A derivation from "to add lips". Originates from the live performance of rap music, where artists often have so-called *hype-man* or *backup rappers*. They emphasise certain lines or words by duplicating them. This gave rise to the idea of using this additional energy in studio recordings and not only doubling words, but also adding new onomatopoeic words. Some of these *adlibs* have now developed into recognisable audio tags for individual rappers.

B Backspin

Originally the name of a physical movement when you turn on your back with your knees bent while doing break dancing. It later became a term used by DJs to turn a record backward and start it again at the beginning of a drum beat. Since 1994, *Backspin* has also been the name of one of the most important hip-hop magazines in Germany.

C Character

Character is basically the term used for all figures in a graffiti picture that are not letters. These can be people, for example, but also animals and other figures.

D Diggin'

The core of hip-hop culture is based on the principle of diggin', digging for exciting content that you (re)mix with other content to create something new. DJs and their literal hunt for new disks led to the conceptual expansion "Diggin' in the crates". Many disks used to be collected in boxes that originally came from milkmen. The term "milk crates" was then abbreviated to "crates".

E End to End

Is also used in the form *End2End, E to E* or *E2E*. This describes a graffiti image that stretches from one end of a train to the other.

F Flexing

A positive form of showing off. It is mostly related to rap in the context of hip-hop – someone "flexed" his rap part. However, this term is also used today to express what a person has achieved.

G Grime

The term grime refers to a style of music from London's East End that has its roots in electronic music, in particular Dubstep, Jungle, and UK Garage. Influenced by dancehall, hip-hop and ragga, grime beats are usually produced in the range from 138 to 144.5 BPM. British rapper Richard Kylea Cowie is considered the founder of grime.

H Hip-Hop

In addition to the genre of music, the term hip-hop also describes the hip-hop subculture with the basic elements of rap (MCing), DJing, breakdancing, graffiti writing and beatboxing. The term itself can be traced back to the two American music pioneers Lovebug Starski and DJ Hollywood.

I Ice

This term from US rap describes the impression left by diamonds, cut stones and generally eye-catching jewellery. Because this jewellery can look like frozen "ice", it is often referred to as "ice" for

J Jam

A hip-hop jam is the original German name for parties from the 1980s onwards, at which hip-hoppers from all four aspects of the culture came together. This was necessary until the end of the 1990s in order to attract a big enough crowd to each event. Hip-hop jams declined in popularity as more individual events in the form of concerts or breakdance events became profitable.

K King of Rap

In 2000, rapper Kool Savas, together with producer Plattenpapzt, released a single and accompanying music video called *King of Rap*. The Berlin-based artist is still associated with this nickname to this day.

Lit

This term is used to describe how great something is. It comes from the concept of igniting something, as in "to light up a fire".

Mantle

Used in rap to say that you will not betray anyone. You put the "mantle of silence" over something or express that you respect this mantle by wearing it.

New York City

The city that never sleeps is considered the original home of hip-hop culture. Numerous rap greats and producers come from Long Island *(De La Soul)*, Brooklyn (Jay-Z), Queens (50 Cent) or Staten Island *(Wu-Tang Clan)*.

Old School

Within hip-hop research and history, old school is a specific era – specifically the years 1973 to 1983. The term was coined by Grandmaster Melle Mel, a long-established MC. He created the term to distinguish the new school of the up and coming *RUN-D.M.C.* crew from its predecessors.

Propz/Props

Giving props to someone else means paying him respect or tribute, already expressed in the civil rights movement by musicians like Aretha Franklin in the song "Respect". The acronym for props is often given as "People Respect Other People Seriously".

Quickpiece

Also called bombing or chrome bombing. It is a very quickly painted (graffiti) image which is less about aesthetic style writing and more about visibility and sheer mass. It is often used to clarify territorial claims and usually only consists of a black outline and a single-color fill-in.

Run-D.M.C.

Band members Jason Mizell (Jam Master Jay), Joseph Simmons (Run) and Darryl McDaniels (D.M.C.) grew up together in Queens, New York City, where they formed the rap crew *Run-D.M.C.* in 1982 after graduating from high school. To this day, the group is one of the most influential hip-hop acts of the 1980s. Mizell, Simmons and McDaniels were instrumental in bringing rap to a wider audience.

S Stan

This expression was invented and coined by US rapper Eminem in his song of the same name from 2000. Since the single on the album The Marshall Mathers LP, the name "Stan" has been used for fanatical people who are so obsessed with others that they could also be called stalkers.

T Top to Bottom

Also *Top2Bottom*, *T to B* or *T2B*. A graffiti term describing when a train carriage has been painted from top to bottom.

U Underground

For many years, hip-hop took place under the media radar, below the line. That is why the place where this culture was celebrated was felt to be "underground". At the same time, people were proud to be part of the *underground*.

V Vibing

On the one hand, a person's vibe is their charisma or aura. On the other hand, vibe also means the mood that you feel at a concert or party, for example.

W Wheels of Steel

The wheels of steel are the tools of the DJs. Their way of repurposing turntables is comparable to the invention of the wheel. The soundtrack for rappers and dancers is created by lengthening so-called breakbeat passages on rock and funk records.

X

The letter X has a special meaning in hip-hop culture. Rappers like Sadat X, Professor X, Overlord X or crews like the X-Clan or DJs like Terminator X have the X in their name in reference to the Civil Rights movement of the 1960s. Activist Malcolm Little no longer wanted to bear the name of his slave owner, but neither did he know the name of his African forefathers. So he chose an X as his last name, which in mathematics stands for an unknown quantity – an act of self-empowerment and liberation.

Y Yo

Yo is an exclamation meant to attract attention. For example, it can mean something similar to "Hey", but also means something like a final agreement – "Yo, let's go".

Z Tech 12

A legendary turntable from Technics / Panasonic. The name refers to the model SL-1210, which is known for its reliability and durability.

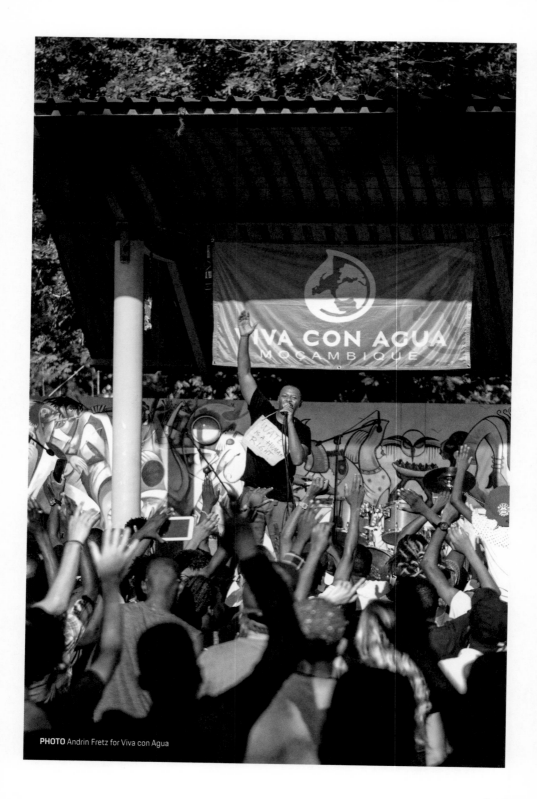

PHOTO Andrin Fretz for Viva con Agua

An organisation to quench the world's thirst

Water is life. And yet roughly 2.2 billion people around the world do not have secure access to clean drinking water. 579 million of them have no access to any drinking water infrastructure. It is this issue that charitable organisation Viva con Agua de Sankt Pauli e.V. has set out to tackle. Its members are committed to ensuring that all people around the world have access to clean drinking water, hygiene facilities and basic sanitation. Water is a human right, and Viva con Agua is standing up for this conviction.

In 2005, FC St. Pauli footballer Benjamin Adrion travelled to Cuba, where he encountered at first-hand the challenging situation regarding the drinking water supply in the island nation. One year after returning to Germany, Adrion launched Viva con Agua de Sankt Pauli e.V. The organisation supports water projects and various campaigns at home and abroad, all in keeping with the motto: "Water for all – all for water".

Viva con Agua is a non-profit organisation. However, it prefers to describe itself as an all-profit organisation. The organisation is consciously active in an environment, in which an informal approach is possible. A major role in this work is played by the universal languages of music, art and sport, with which Viva con Agua strives to persuade people to engage in the issue of clean drinking water, and to acquire donations.

The money raised goes towards the WASH project. WASH stands for Water, Sanitation and Hygiene – the key areas, in which Viva con Agua is involved. The charity runs projects together with local and international partner organisations in various countries. The focus is currently on Ethiopia, Uganda and Nepal.

Mobile drilling equipment in Ethiopia – social alternatives to mineral water in Germany.

In Ethiopia, for example, roughly 31 percent of the population currently has no access to clean drinking water. 93 percent lack access to basic sanitation. Despite this, the country has made great progress in terms of water supply and sanitary provision in recent decades. Viva con Agua is supporting one project with the mobile drill known as "Johns Rig". Over a period of eight years, the drill will, among other things, be used to carry out work on 210 construction projects aimed at facilitating the supply of drinking water.

In another project in Ethiopia, Viva con Agua is working with partner "Menschen für Menschen" to supply Ijaji Town, which is the main village in the Illu Gelan district, roughly 200 kilometres west of Addis Ababa. The goal is to sustainably improve living conditions for the 20,000 inhabitants. According to the organisation's own information, Viva con Agua has managed to increase the percentage of the population with access to water from 19 to 41 percent.

The Viva con Agua family is growing all the time. Crews of Viva con Agua volunteers can be found in countless German cities. Switzerland, Austria, the Netherlands, Uganda and South Africa also have independently registered Viva con Agua associations. The limited company Viva con Agua Wasser GmbH was founded in 2010. The social business's goal is, on the one hand, to establish social alternatives on the mineral water market and, on the other hand, to promote

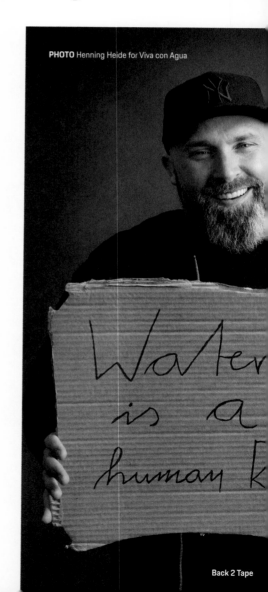

PHOTO Henning Heide for Viva con Agua

the consumption of tap water. More social enterprises followed, in the form of Viva con Agua Arts and Goldeimer gGmbH. The Viva con Agua Foundation was founded in 2010 as a cultural stronghold and to secure Viva con Agua in the long term. This way, the ideals and visions of the organisation, which has a positive effect on the living conditions of countless people around the world, never go forgotten.

Back 2 Tape meets Viva con Agua.

Water for all – all for water. This also applies to the *Back 2 Tape* project and this book. Together with Porsche and Niko Hüls, we have decided to donate all proceeds from the sale of the book to Viva con Agua and its projects all over the world. We would like to thank everyone who, in purchasing this book, has helped to quench the world's thirst.

VIVA CON AGUA

Viva con Agua supports water projects with the vision "WATER FOR ALL – ALL FOR WATER!"
Together with the air we breathe, water is a basis of all life and a central human right. Viva con Agua is pursuing a vision to ensure that all people have access to clean drinking water, hygiene facilities and basic sanitation. 2.2 billion people around the world have no secure access to clean drinking water. Of them, roughly 579 million do not have access to any drinking water infrastructure.

↗ www.vivaconagua.org

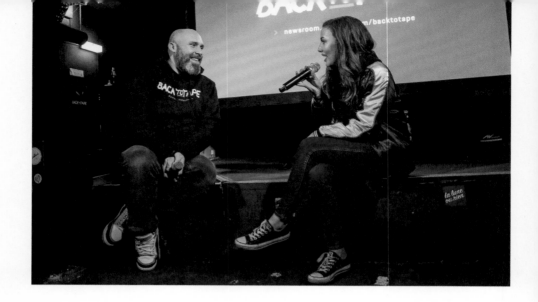

More than just a track

On the trail of rap, graffiti, DJing and breakdance in Europe: in 2018 (*Back to Tape*) and 2020 (*Back 2 Tape*), Porsche presented two full-length video documentaries on hip-hop culture in Europe together with Niko Hüls and hip-hop magazine *Backspin*. By now the films have been seen by more than two million people, and have also won around 20 international communication awards. Both parts can be viewed free of charge on Porsche NewsTV and YouTube, plus lots of background material. Start the film!

 BACKto**TAPE**

Back to Tape (2018) feat. Samy Deluxe, Moses Pelham, Namika, Curse, Falk Schacht, Roger (Blumentopf), David Pe (Main Concept), Toni-L, Scotty76, Duan Wasi (Massive Töne), DeluxeKidz e.V. and Beat Boy Delles.

Roger, Blumentopf (Munich – Rap)
03:23 – 09:30
David Pe, Main Concept (Munich – Rap)
09:31 – 15:49
Toni – L (Heidelberg – Rap)
15:50 – 23:01
Scotty76 (Stuttgart – Graffiti)
24:07 – 30:28
Duan Wasi (Stuttgart – Rap/Producing)
30:29 – 38:30
Namika (Frankfurt – Rap)
38:31 – 45:36
Moses Pelham (Frankfurt – Rap)
47:01 – 54:53
Curse (Berlin – Rap)
54:54 – 1:03:06
Samy Deluxe (Hamburg – Rap)
1:03:07 – 1:09:30
DeluxeKidz e.V und Beat Boy Delles
(Hamburg – Breakdance)
1:09:31 – 1:16:45
Falk Schacht (Hamburg – Journalist)
1:16:46 – 1:24:09

 BACK2TAPE

Back 2 Tape (2020) feat. Kool Savas, Lord Esperanza, Falsalarma, Pete Philly, Josi Miller, Rodney P, Gebuhr, Michael "Mikel" Rosemann (Flying Steps), Sune Pejtersen, Nicolas Couturieux, Edson Sabajo, Lars Pedersen, El Xupet Negre, Miriam Davoudvandi and Apex Zero.

El Xupet Negre (Barcelona – Graffiti)
02:09 – 06:19
Falsalarma (Barcelona – Rap)
06:20 – 11:16
Nicolas Couturieux (Paris – Graffiti)
11:17 – 15:25
Lord Esperanza (Paris – Rap)
15:26 – 22:35
Gebuhr (Copenhagen – Rap/Producing)
22:36 – 24:46
Sune Pejtersen (Copenhagen – Breakdance)
24:47 – 28:24
Lars Pedersen (Copenhagen – Graffiti)
28:25 – 35:04
Apex Zero (London – Journalist)
35:05 – 38:39
Rodney P (London – Rap)
38:40 – 45:24
Edson Sabajo (Amsterdam – Sneaker/Producing)
45:25 – 51:37
Pete Philly (Amsterdam – Rap)
51:38 – 56:43
Josi Miller (Berlin – DJ)
56:44 – 1:00:48
Michael "Mikel" Rosemann, Flying Steps (Berlin – Breakdance)
1:00:49 – 1:06:32
Miriam Davoudvandi (Berlin – Journalist)
1:06:33 – 1:09:38
Kool Savas (Berlin – Rap)
1:09:39 – 1:17:53

Imprint

Bibliographic information published by the Deutsche National-
bibliothek. The Deutsche Nationalbibliothek lists this publication
in the Deutsche Nationalbibliografie; detailed bibliographic data
are available in the Internet at http://dnb.dnb.de.

© Delius Klasing & Co. KG, Bielefeld

1st edition, April 2021
ISBN 978-3-667-12178-3

Publisher
Dr. Ing. h.c. F. Porsche AG,
Öffentlichkeitsarbeit, Presse, Nachhaltigkeit und Politik,
Dr. Sebastian Rudolph
Niko Hüls aka Niko Backspin, Backspin Media

Idea, Concept & Projet management
Marco Brinkmann, Delius Klasing Corporate Publishers
Julian B. Hoffmann, Dr. Ing. h.c. F. Porsche AG
Sven Labenz, Faktor 3 AG

Creative Direction
Roman Jonsson, Faktor 3 AG

Art Direction
Daniel Rivas, Faktor 3 AG

Texts
André Bosse, Sven Christ, Bastian Fuhrmann, Sven Labenz,
Till H. Lorenz, Jonas Mielke, Ralf Niemczyk, Falk Schacht,
Felix Schulz, Julia Tawalalli

Head of Photography & Cover photo
Markus Schwer

Photography
All Photos by Markus Schwer
Further images by Simone Michel, Philipp Rothe, Dr. Ing. h.c.
F. Porsche AG sowie Claudio Schwarz, Patrick Rosenkranz,
Roman Kraft, Erwan Hesry, Alexander Kagan, Sander Crombach,
Lindsay Martin, Mihail Macri, Gordon Cowie, Dom Hill,
LexScope, Chris Benson, Erwan Hesry, Gracia Dharma, Kwesi
Phillips, Arnaud Mariat, Marco Lastella, Jean Carlo Emer, Jeison
Higuita, Rinke Dohmen, Mark Sayer, Walid Hamadeh, Annie
Spratt, Victor Xok, DiChatz, Mathieu Chassara, Thiebaud Faix,
Nelson Ndongala, Matteo Catanese, Rom Matibag, Tim Hufner,
Brad Neathery, William Krause, Mika Baumeister, Clay Banks,
Elio Santos, Annie Spratt, Mirta Fratnik, Zac Ong, BP Miller,
Lesia Gant, Kyle Austin, Steve Harvey, Peter Fogden, Matthew
Hamilton, Zaya Odeesho (all via unsplash.com/Unsplash Inc).

Translation
Steven Barraclough

Production
Axel Gerber

Reproduction & Artwork
Krogmann-Giebelstein GmbH & Daniel Rivas, Faktor 3 AG

Printed by
Optimal Media, Röbel

Printed in Germany 2021

Delius Klasing Verlag GmbH
Siekerwall 21
D-33602 Bielefeld
Telefon 0521/55 9-0,
E-Mail: info@delius-klasing.de
www.delius-klasing.de

FAKTOR 3 AG
Kattunbleiche 35
D-22041 Hamburg
E-Mail: info@faktor3.de
www.faktor3.de

Consumption details
Porsche Cayenne S Coupé (as of 3/2021)
Fuel consumption, urban: 12.8 l/100 km
extra-urban: 8.2 – 7.9 l/100 km
combined: 9.9 – 9.7 l/100 km
CO_2 emissions combined: 225 – 222 g/km

Note
Niko Hüls and Porsche's roadtrip through Europe was
Produced in fall 2019 before the outbreak of the corona virus.
Porsche, Backspin and the artists, photographers and agencies
involved are aware of their social responsibilities and are
advising against recreating such a trip until it is safe and travel
is permitted.

newsroom.porsche.com/backtotape
www.back2tapebook.com